Please return this book on or before the date shown above. To renew go to www.essex.gov.uk/libraries, ring 0845 603 7628 or go to any Essex library.

Essex County Council

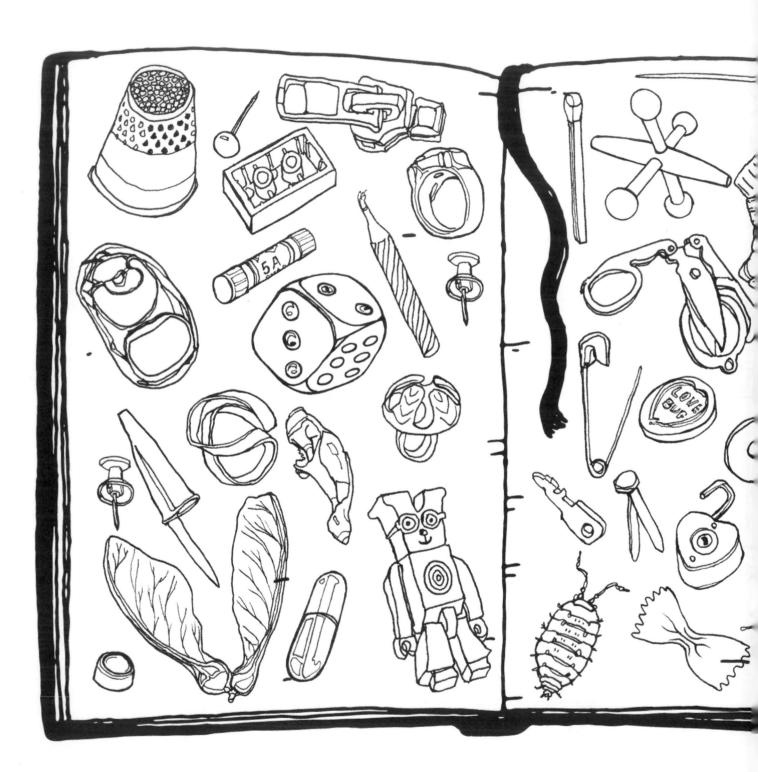

JUST
DRAW
IT!

Sam Piyasena and Beverly Philp

Search Press

A QUARTO BOOK

Published in 2013 by
Search Press Ltd
Wellwood
North Farm Road
Tunbridge Wells
Kent TN2 3DR

ISBN: 978-1-8444-8898-8

QUAR:DAWB

Conceived, designed and produced by
Quarto Publishing plc
The Old Brewery
6 Blundell Street
London N7 9BH

Project editor: Lily de Gatacre
Copy editor: Liz Jones
Designer: Karin Skånberg
Proofreader: Michelle Pickering
Indexer: Ann Barrett
Picture researcher: Sarah Bell

Creative director: Moira Clinch
Publisher: Paul Carslake

Colour separation in Hong Kong by Modern
Age Repro House Limited
Printed in China by Hung Hing

10 9 8 7 6 5 4 3 2 1

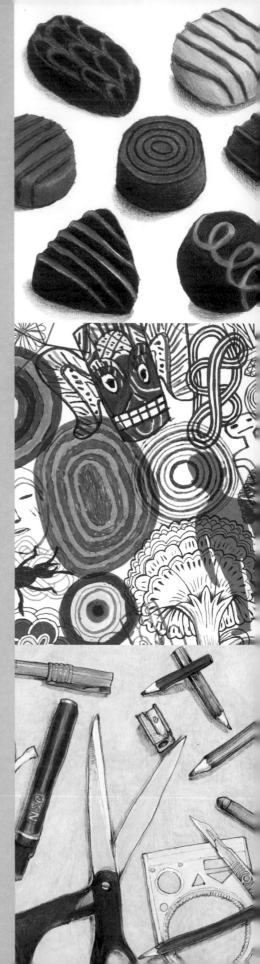

Contents

Line and Mark Making
page 10

Tone and Form
page 30

Composition, Perspective and Viewpoint
page 60

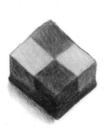

Movement and Gesture
page 84

Pattern and Texture
page 98

Observation, Exploration and Imagination
page 110

Foreword

Both of us spent most of our childhoods bent over a sheet of paper with a pencil in one hand and a glass of lemonade in the other. Drawing was an escape from the world, but also a way of making sense of it. Many young children feel this way about drawing. However, as we get older the focus in school is shifted towards drawing realistic representations of what we see. Sadly, for most children, all the joy and freedom of mark making is lost forever in these years. It is such a shame that from this point on, the practice of drawing becomes the preserve of the few who are deemed talented or gifted.

Therefore, it is not surprising that most people go through life feeling incredibly inhibited and lacking in confidence about putting pencil to paper. This fear of drawing is not exclusive to those who work outside of the creative industries. There has been a growing trend in many art schools to marginalise drawing in favour of digital skills. This book will reconnect you with those unadulterated childhood experiences of simply enjoying the process of making marks on paper.

Pick up your pencil and just draw it!

Ian

B.P.

pattern. Finally, the last chapter will encourage you to challenge your preconceptions about drawing and explore your creative spirit. Most importantly, this book will help you to innovate and express your emotions and passions through drawing.

First, we will explore line and mark making, which is at the very heart of drawing itself. We will then look at the use of light and shade to give form to your drawings. The often tricky task of representing three-dimensional forms on a flat picture plane will be dealt with in the following chapter. We will help you to infuse a sense of movement in your drawings and will open up the possibilities of using texture and

In this chapter, we are going to look at the very foundation of drawing itself. Having the confidence to make marks is the most important starting point for every draughtsman and will give you the freedom to express yourself creatively through your drawings. The quality, weight and intensity of a line can be applied in many different ways to convey shape, form, movement and tone.

Line and Mark Making

'There are no wrong notes; some are just more right than others.'
Thelonious Monk

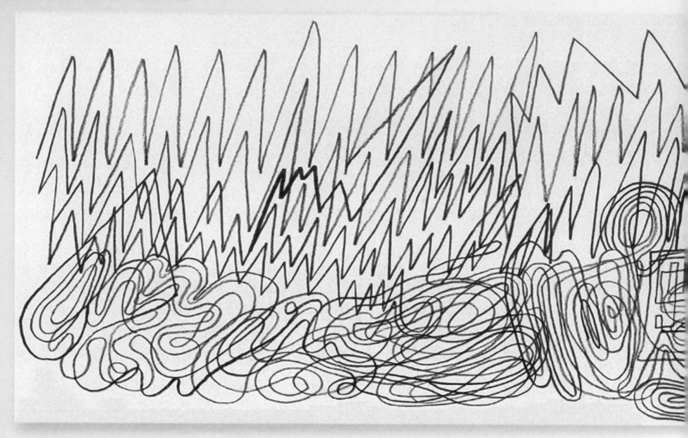

Sound and Vision

Artists throughout history have been inspired by music, and many make reference to it in their work.

The Russian artist Wassily Kandinsky, for example, wanted to convey the complexities of classical music through his art. 'Wild, almost crazy lines were sketched in front of me', he proclaimed after watching a production of Wagner's opera 'Lohengrin'. Kandinsky's pioneering abstract works were an expression of this interplay between sound and vision.

When drawing, many artists have the white noise of music playing in the background. However, this exercise is about visualising sound; so the music takes centre stage, becoming the main focus of your drawing. Rhythm, harmony and texture are some of the common components shared by the two art forms that you can explore in your mark making. Take your pencil in your hand like a conductor holding a baton, and follow the ebb and flow of a musical composition.

1. Stick a very large sheet of paper or a section of lining wallpaper on a wall.

2. Use only one drawing implement for this exercise – either a soft pencil or a charcoal stick.

3. Now play a piece of music of your choice. Instrumental is best, as music with lyrics can be a distraction and may produce a literal interpretation of the song.

4. Immerse yourself in the music, and try to convey its visceral qualities on the paper. This is very much about letting go and exploring the potential of abstract line making.

5. The rhythm of the music can also dictate your physical response to the drawing. It is important not to deliberate over your marks; the line should move seamlessly in time with the music. It is very much like a performance.

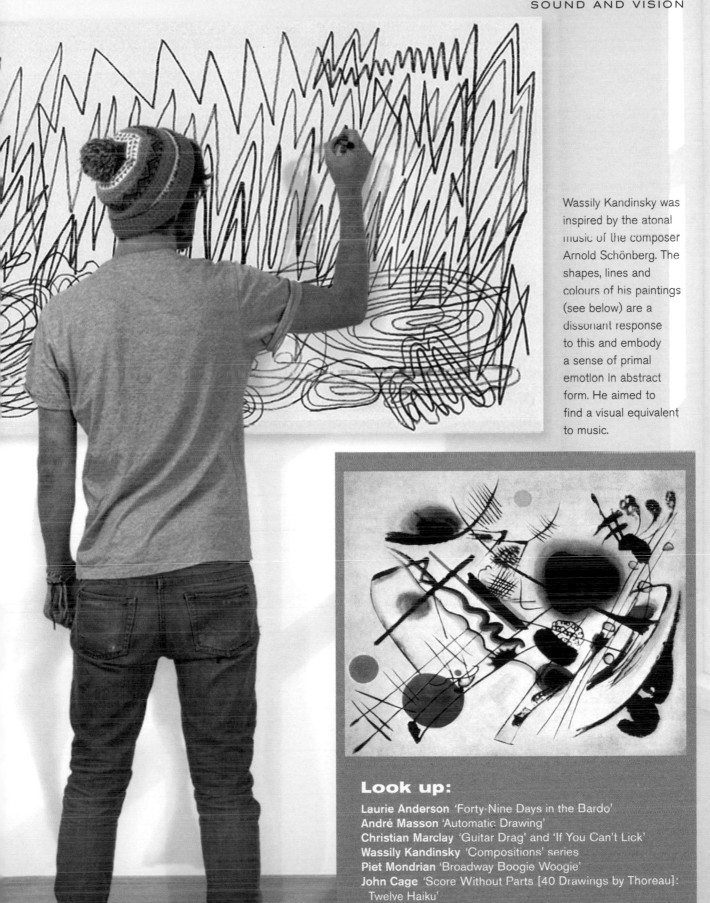

Wassily Kandinsky was inspired by the atonal music of the composer Arnold Schönberg. The shapes, lines and colours of his paintings (see below) are a dissonant response to this and embody a sense of primal emotion in abstract form. He aimed to find a visual equivalent to music.

Look up:

Laurie Anderson 'Forty-Nine Days in the Bardo'
André Masson 'Automatic Drawing'
Christian Marclay 'Guitar Drag' and 'If You Can't Lick'
Wassily Kandinsky 'Compositions' series
Piet Mondrian 'Broadway Boogie Woogie'
John Cage 'Score Without Parts [40 Drawings by Thoreau]:
 Twelve Haiku'

Walk the Line

This task is a great excuse to get out and about. We all have our own unique take on the world; so what visually excites you, may not excite others. Drawing in public can be quite nerve-wracking; so hopefully this exercise will help you confront your inhibitions by taking you out of your comfort zone.

Edit the essential information that you feel best describes your journey. You will learn about the simplicity of drawing with pure line. Your hand and eye will work in conjunction to develop your concentration.

Then, we continue past a hand-painted sign on a gymnasium window.

Start here
We start our journey looking through the window of the local sports shop.

1. You are going on a walk. Take a pen or a sharp pencil and a sketchbook.

2. Step outside and begin to draw without taking your pen off the page.

3. Draw something interesting that you see. Let the flow of your line connect with the direction of your eyes. If you are unhappy with a line, don't correct it but draw over the original line. You will learn by making mistakes.

4. Now move on about 50 paces, look around and draw something else that catches your eye. Observe and record.

5. Repeat the exercise at 50-pace intervals, remembering to keep your pen on the page.

6. Carry on with the exercise until you reach a cafe and have a well-deserved cup of coffee. Draw the cup, too.

Finally, we go another 50 paces, to an abandoned mobility scooter parked on the pavement.

'Drawing is like taking

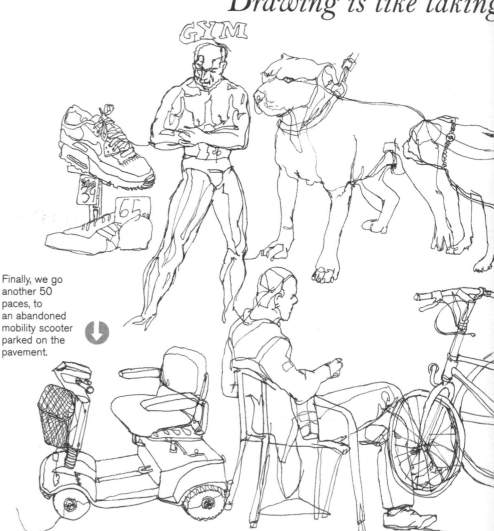

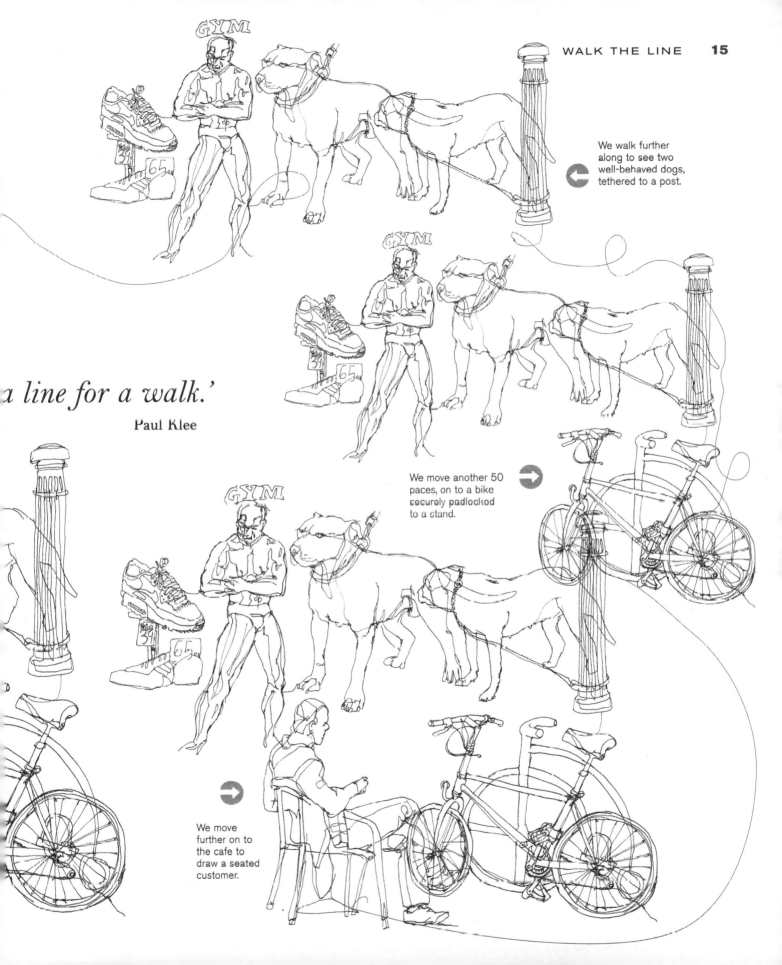

We walk further along to see two well-behaved dogs, tethered to a post.

a line for a walk.'

Paul Klee

We move another 50 paces, on to a bike securely padlocked to a stand.

We move further on to the cafe to draw a seated customer.

On the Move

Drawing with friends around you can be intimidating, as they usually expect your drawings to be 'a likeness' or perfect. An easy way to start is while you are on the move in some mode of transport: a train, a bus or a car. Who could possibly expect a perfect drawing when you are being bumped around? What's more, the movement will give your line a lively, spontaneous quality that is impossible to create if working normally. Not only will it make the journey pass more quickly, but you will have a great memory of the day, too.

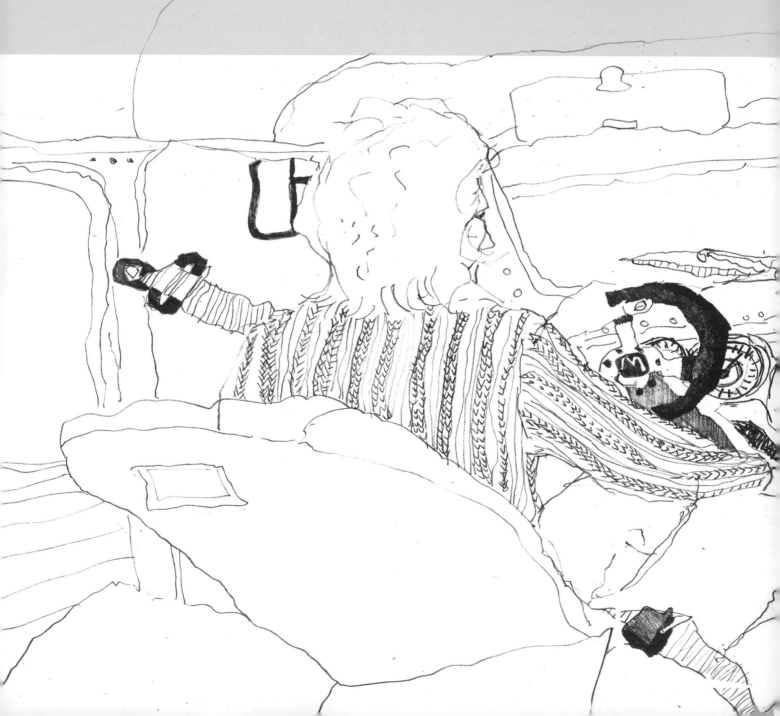

1. Sit comfortably and figure out the scope of the interior you want to draw. Then roughly look at the area and divide it into quarters. Here, you can see that the windscreen wipers sit roughly halfway down the paper, and the left edge of the rearview mirror is on the vertical midpoint.

2. Divide your paper into the same quarters, with faint vertical and horizontal lines. This will ensure that you can fit the interior panorama onto your paper.

3. Now, in each quarter, draw the outlines of the basic shapes of the seats, dashboard and the figures.

4. Having fitted the basic shapes into your drawing, have some fun drawing the dials, buttons and switches. You can shade in some of the darker areas.

5. Don't worry about the wobbly lines. It's all part of the fun of drawing on the move – and watch out, because it can become addictive!

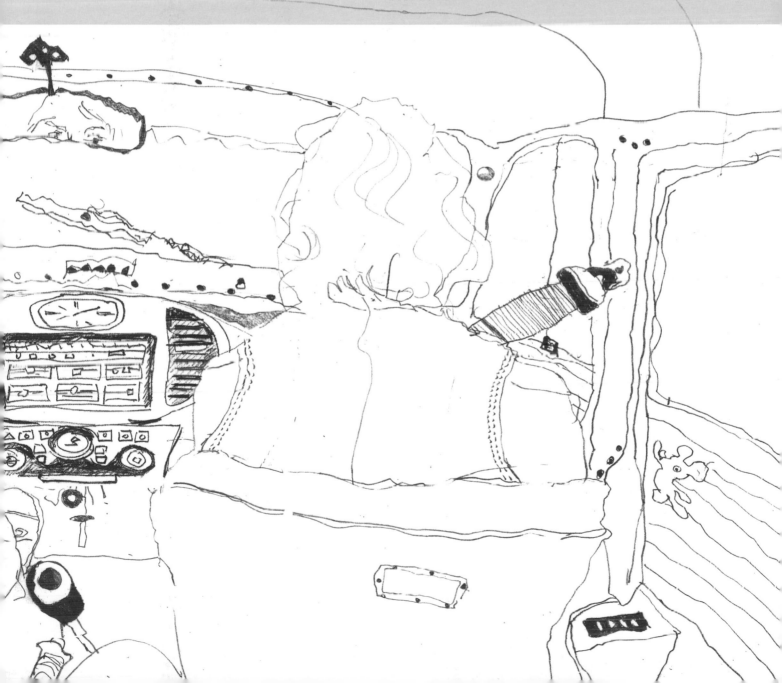

It's really liberating to get out into the fresh air and be close to nature. It helps you to clear your thoughts, heightens your senses and energises your creative spirit.

If You Go Down to the Woods Today

Roll up some large sheets of heavyweight paper. Pour some Indian ink into a wide-rimmed container and take a walk in an area of forest or woods. Absorb the natural surroundings as you walk. Go rooting around and find a selection of sticks of varying lengths and widths. You will use these sticks to discover the joys of gestural mark making.

Beverly gets back to nature (below) and the forest provides her drawing tools and her inspiration.

1. Place the paper down on an even surface and secure it with some rocks.

2. Take inspiration from the natural forms that you see around you. Take a deep breath, dip the end of your stick into the ink and begin to make marks on the paper.

3. Manipulate the stick so that you create a variety of marks.

4. Use your entire body to influence the marks that you are making. Where are the movements coming from: the shoulder, elbow or torso?

5. Have fun – try controlling the stick by holding it with both hands and wielding it like a light saber!

6. Finally, try out a variety of sticks and compare the wide range of marks that you can produce with them.

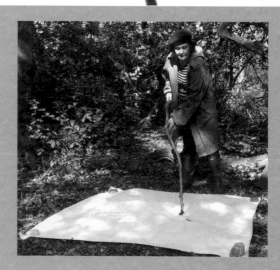

Drawing Breath

Zen artists sought perfection by capturing the spirit and nature of life with a simple gestural mark.

With this task, you are going to make a simple transient mark. Your drawing will be completed in a fleeting moment – a non-permanent expression on a pane of glass. It will help you to feel less precious about your mark making and will develop your imagination.

Do you remember doodling on a steamy bus window or in the car on a long journey? No drawing materials are required for this exercise, other than your index finger, a window and your breath. It's inexpensive, spontaneous and immediate.

1. Breathe onto the window and with your index finger make a very quick drawing. If you want to create a larger 'canvas', use the steam from a kettle.

2. You can draw anything that comes to mind. Try to make your marks in an unselfconscious way, as the drawing can be wiped away as quickly as it was created. Simply steam up the window once again and start another drawing.

3. There may be drips that run down the steamy window – integrate these into your drawing.

4. Use the side of your nail to create more delicate lines.

5. Try expressive lines with as little detail as possible.

6. Use your other fingers to wipe away larger areas.

Look up:

Yosman Botero 'Condensation' series
Ben Long 'The Great Travelling Art Exhibition', www.benlong.co.uk
Scott Wade www.dirtycarart.com

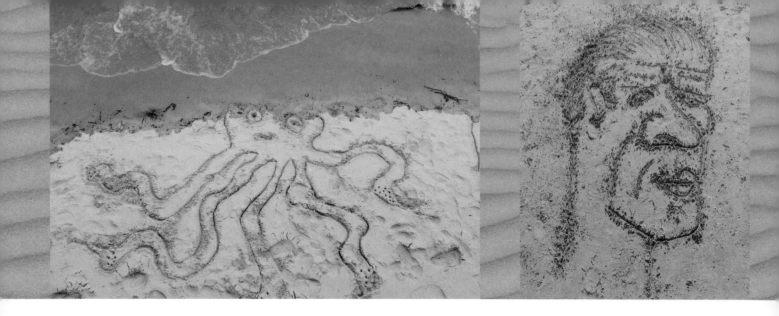

A Line in the Sand

There's little better than taking in the sea air, walking barefoot in the sand, with the waves lapping on the shore. All the stresses of life seem to disappear, and it can bring back nostalgic childhood memories of idling away the hours, playing on the beach – ice creams, sandcastles, paddling and having fun.

Drawing in the sand is very much about having fun and being playful. You will free up your drawing technique, and it's also a great excuse to hit the beach! There is no point in being too precious about your masterpiece, as the tide will eventually erase all traces of its existence.

Look up:

Jim Denevan 'Surfers in Circle', www.jimdenevan. com/sand

Jim Denevan uses a variety of materials, including driftwood, rakes and even chain-link fences, to draw beautiful geometric patterns in sand. He created what some say is the largest drawing in the world in Nevada's Black Rock Desert in 2009.

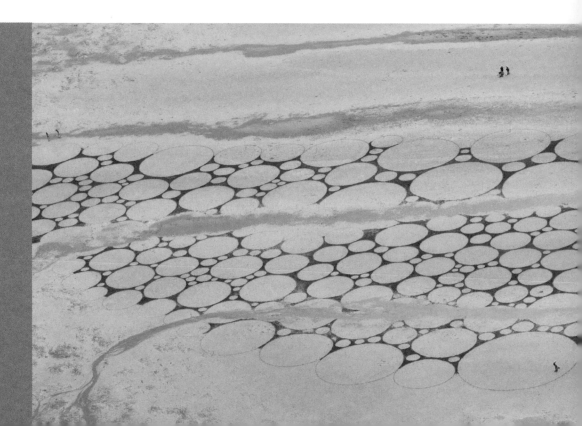

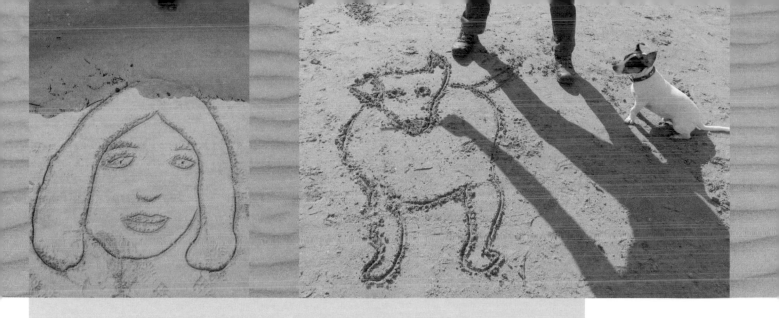

1. Go foraging for driftwood, shells and pebbles to use as drawing implements.

2. Sketch out a line drawing in the wet sand. The beach is your canvas. It can be a realistic image, a pattern or something purely abstract. Be intuitive and let go of your inhibitions.

3. React to the quality of the sand. If the sand is moist, it is easier to make marks; but work with what you have, whether it's wet or dry, soft or firm.

4. Sand drawing is as ephemeral as the tide itself; but if you want to keep a record, there's no reason why you shouldn't take photographs. They will also remind you of your perfect day, doodling in the sand.

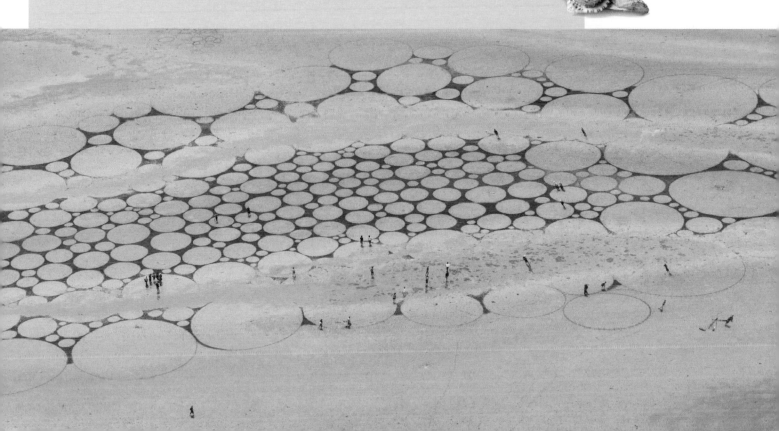

A Stitch in Time **Put down your pens and pencils, and pick up a needle and thread.**

You will be exploring line making through the use of embroidery. This task will take you out of your comfort zone, helping you to make marks in a slower and more contemplative way. Don't worry if you've never used a needle and thread before. This is not an exercise in technical perfection – just have fun!

1. You will need a B pencil, needle, thread and fabric. The most commonly used embroidery fabric is Aida cross stitch fabric, which is an even-weave cotton that has a natural, mesh-like texture. Failing this, calico, silk or just plain cotton will do. However, if you don't use Aida stitch fabric, you may need an embroidery hoop to help keep your fabric taut.

2. Lightly draw a simple image onto the fabric. This will act as your guide.

3. Follow this line with your needle and thread. Feel free to stray from this line if you wish.

Look up:

Jenny Hart Embroidered portraits, http://jennyhart.net
Richard Saja Embroidered works of art, http://historically-inaccurate. blogspot.co.uk
Louise Bourgeois 'Ode à L'Oubli'

Sign on the Blotted Line

This exercise will help you to take a step back from your familiar drawing techniques, and will encourage you to consider the different qualities of line that are possible. Losing control of the line will give you the excitement of chance. Some marks will look great and others won't.

When Andy Warhol was working as a commercial artist in New York in the 1950s, he adopted this drawing technique, which helped him to reproduce images, giving them a blotted-line effect. This exercise will ask you to emulate his innovative technique.

1. Draw an image in pencil on a piece of non-absorbent paper. Stick a piece of absorbent paper (perhaps watercolour) to one side, so that the absorbent paper can be folded over your image like a greeting card.

2, 3, 4, 5. Begin to trace the pencil line drawing with Indian ink, and at every stage fold over the absorbent paper and press down. Keep pressing the two sheets together and watch the image evolve on the absorbant sheet. You will create what Andy Warhol called an original and a copy. You can then replace the absorbent paper and repeat the process to make more copies. Every drawing is unique.

6. Compare and contrast the different qualities of line that you have created. Do the line thicknesses differ? Are the serendipitous blots interesting?

Experiment with different materials – for example, you can try a very soft pencil and make a monoprint.

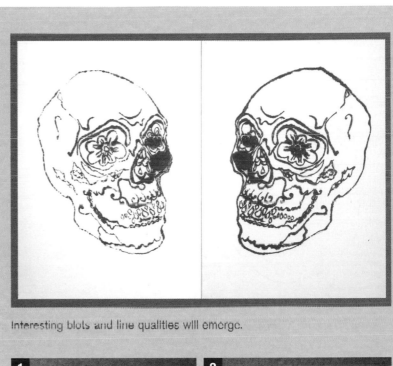

Interesting blots and line qualities will emerge.

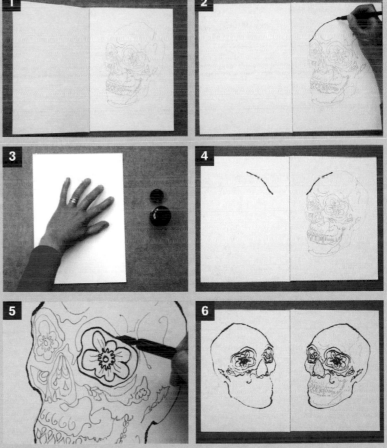

On Its Head

We recognise objects through a combination of learned information and visual clues, and our perception of those objects is challenged if they are inverted. Have you ever tried to read upside down, for example? It can be incredibly disorienting and the words are very difficult to decipher.

words are very difficult to decipher.
tried to read upside down, for example? It can be incredibly disorienting and the
and our perception of those objects is challenged if they are inverted. Have you ever
We recognise objects through a combination of learned information and visual clues,

On Its Head

In 1969, Georg Baselitz, the neo-Expressionist painter, decided to hang his work upside down. He used this device to draw attention to the physical makeup of his images and to distance the viewer from any form of rational representation.

For this exercise, you will try an experiment. You will draw an outline of the image of the boxer exactly as it appears opposite. Focus on the marks that you put down rather than the depiction of the image itself. Drawing an inverted image will force you to concentrate on the patterns, shapes and contours, rather than the figurative subject matter. Don't be scared; this exercise will surprise you and will ultimately give you confidence in your drawing abilities.

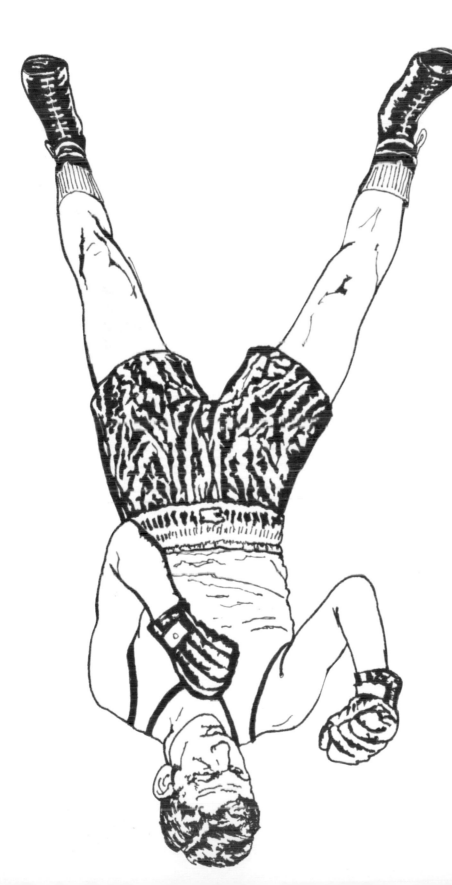

1. Place the upside-down image of a boxer in front of you and study it for five minutes.

2. Take a pen or pencil and begin to reproduce the image exactly as you see it (upside down).

3. Begin by outlining the most prominent shapes and gradually piece them together as you go.

4. Carefully look at the contours and lines that you are making, and try to see them in a purely abstract way. Try not to think of the shapes in any kind of figurative context.

5. Take your time and feel your mind begin to focus on the shapes and patterns. It might help you to see the image as a visual riddle to be pieced together, bit by bit.

6. Finally, turn your drawing and the picture the right way up. You will be amazed at how accurately you have reproduced the image. Your logical, rational thoughts have been erased, and this has freed up your ability to faithfully represent the image.

Look up:

Georg Baselitz 'Portrait of Franz Dalhem'
Antony Gormley 'Feel'

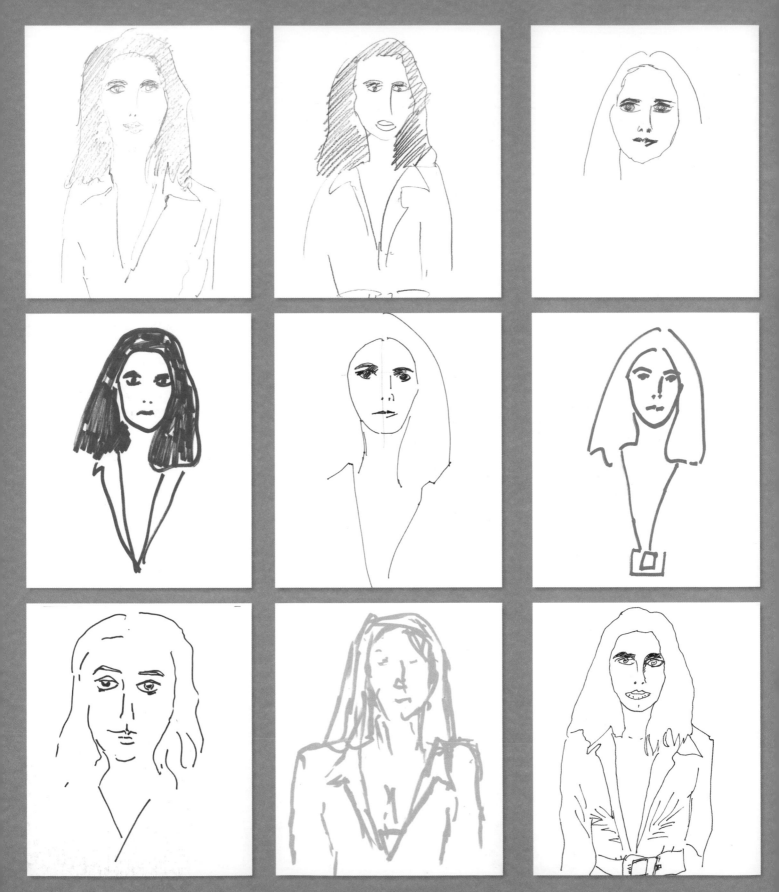

In a Minute

It's very common for beginners to lack confidence in their drawing skills, and some even feel that they can't draw at all. Often this notion has been instilled in the psyche in childhood, when a callous word about an early drawing may have implanted negative associations.

Now it's time to forget the past and think positively. You can do it! Everyone can draw. Like everything in life, it takes practice and confidence to improve your skills.

Speed drawing is a really good way to get rid of inhibitions, and is the perfect exercise to fit into a busy life. Take a sketchbook with you wherever you go and make speed drawings of the people and things around you.

This is a great way to loosen up your drawing style – don't agonize over the marks you make. This is the drawing equivalent of a journalist taking shorthand notes. Recording what you see as quickly and as accurately as possible is a great skill to learn. Set your watch, take a deep breath, relax and begin.

All the drawings here have been completed in the allotted time by different artists. They all drew the same person with sometimes very contrasting results. Notice the variety and quality of line among the pictures. Some have failed to complete the task, but all have managed to at least draw the subject's facial features.

00:59

1. Take a felt-tip pen and find something that you can time yourself with (e.g., an egg timer, stopwatch or clock).

2. Set up your sketchpad and ask someone to sit for you. It'll have to be a self-portrait if no one is willing.

3. Try to capture the essence of what you see. Don't ponder over the marks you are making; you haven't time. Let your hand and eye simultaneously connect with the page. Simply let your pen flow and respond to what you see before you, in a spontaneous way.

Look up:

Pablo Picasso and Gjon Mili Light drawings
Edgar Degas Ballet dancer drawings

How Long is a Piece of String?

In the 1960s, there was a craft craze for 'string art'. Bright geometric patterns were made by winding string around a grid of nails on a felt-covered board.

This exercise pays homage to this popular technique; the difference is that there are no nails and rigid structures, only string. You will use a ball of string, with the aid of glue, to loosely 'draw' your subject matter. You don't have to faithfully reproduce what is before you, and it helps if your subject matter has curvaceous contours. For example, the human figure, rolling landscapes and – in keeping with the 1960s theme – flowers and an E-type Jaguar sports car.

Look up: Cornelia Parker 'The Distance [A Kiss with String Attached]', **Denise Lai** 'Sneaker Pimp' poster and **Debbie Smyth** Thread art, www.debbie-smyth.com.

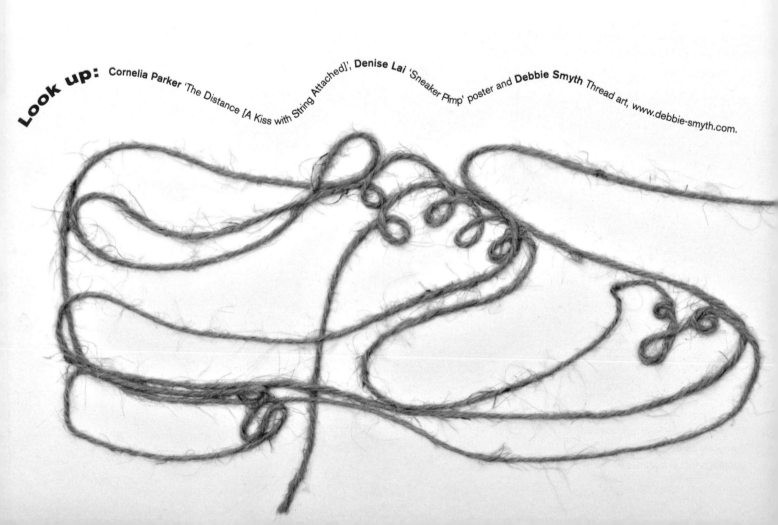

1. You will need a ball of brown string, a sheet of very thick paper or, some PVA glue and a plastic glue scraper.

2. Unravel a length from your ball of string, without cutting it. Cover the sheet of paper with glue. The glue sets very quickly, so you will have to work fast. Alternatively, you can recoat areas that have dried with more glue.

3. Look closely at your subject matter and follow its shape with the string. Wind and bend your string, pressing it down, following the contours of the object.

4. Gently tease and manipulate the string. It is a natural fibre and will try to find its own direction. Dictate where it should fall, but at the same time work with its natural twists and curves. Apply enough PVA glue for the string to stick effectively. This is a tricky process, but stay with it. It can also be quite a messy process, but that's all part of the fun.

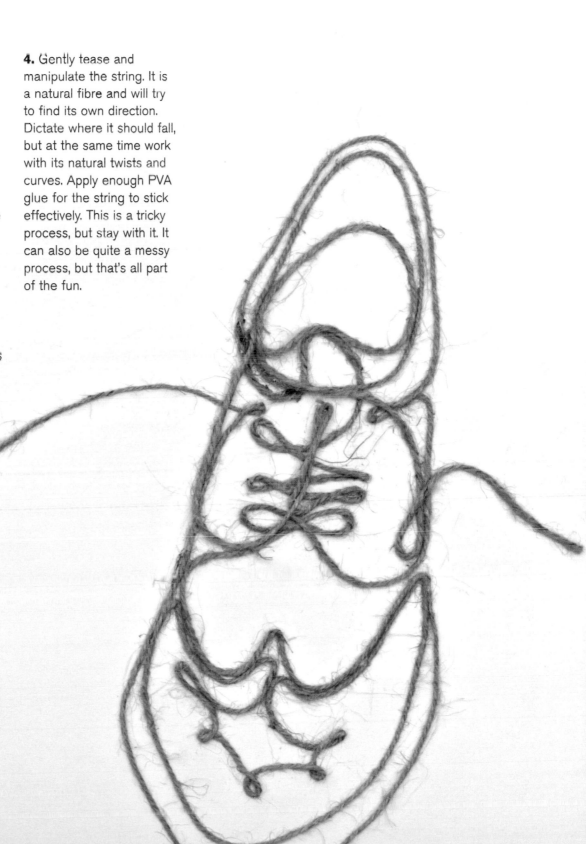

CHAPTER

The exercises in this section will help you to grasp the powerful effects of light and shade in representing form. You will create a sense of volume in your drawings by exploring graduated tone, shadows and highlights. You will also utilise techniques such as hatching, cross-hatching and directional and sporadic mark making to give shape to your drawings.

Tone and Form

'There is no light painting or dark painting, but simply relations of tones.'
Paul Cézanne

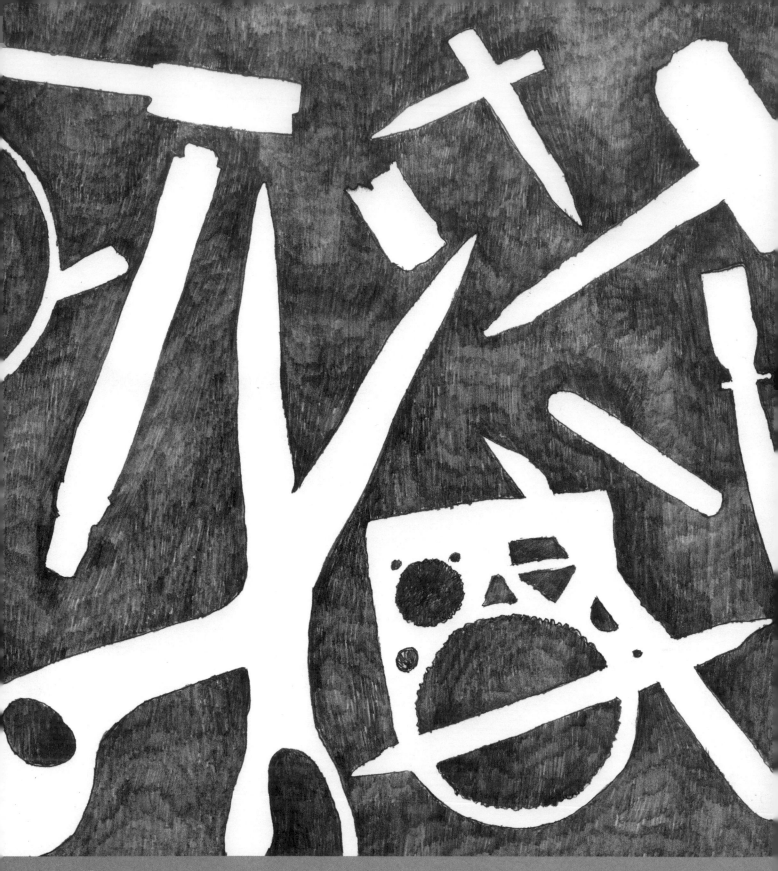

Look up:

Rachel Whiteread 'House'
Man Ray Rayographs

Seeing the Shapes

Many artists are inspired by the negative – the spaces not within, but without. Man Ray, for example, created negative images that he called 'Rayographs', using objects, light, photographic paper and chemicals in a darkroom. But all artists can improve their drawing by taking time to 'see' the negative shapes, because it helps to better capture the positive shapes.

1. Choose some drawing equipment: pencils, crayons, biros, markers, a sharpener, a knife, scissors, anything you have.

2. Place them on a flat surface so that they create a kind of surface pattern.

3. Frame the composition with paper or rulers, so that you are looking at a square composition.

4. In your mind, eliminate the positive shapes of the objects in your composition, and focus instead on the negative spaces – the shapes between the objects.

5. Start to outline one of the larger areas of negative space. In the example on this page, there is one very large area of negative space and 14 smaller ones.

6. Consider the edges and contours and take account of the entire picture. Break down the negative spaces into separate shapes and gradually the picture will materialise before you. Visually measure the distances between objects, trying to keep them all in proportion.

7. Begin to shade the areas you have outlined.

8. When you draw in this way, it will help you think about your drawing more objectively. By detaching yourself from the actual objects, it will help you to think about the relationship between them. Ultimately, it will show you that by emphasising the negative space, you get a new appreciation of the subject of your drawing.

9. Now draw your composition as the positive, concentrating this time on the objects, and notice how you are thinking about this drawing in a completely new way.

When we compare the two images, the monotone arrangement clearly suggests shape and pattern. We are able to focus on the structure and composition of the piece. When we study the colour image, our focus is more on tone and form. It is always useful to understand negative and positive space, as this will help to enhance your final drawing.

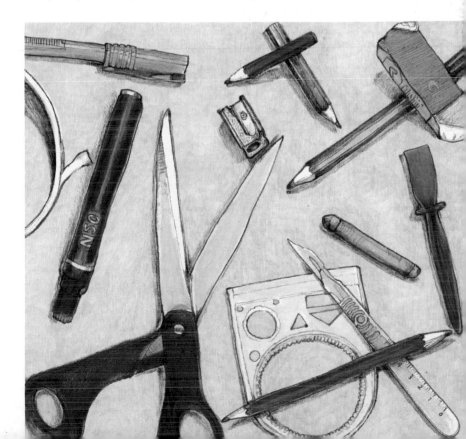

Stand directly in front of your sculpture and start to draw.

Move 90 degrees and notice how the height of the sculpture might alter with the change of viewpoint.

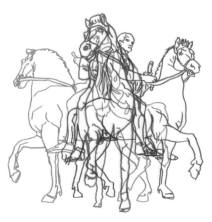

As you move around, the different viewpoints merge together to form a cohesive pattern.

Round and Round

This exercise will help you to understand and explore the three-dimensional nature of your subject matter.

Find a sculpture in a public place or a museum that you can walk around. View the sculpture from different angles and draw its contours with different colours.

When you look at the form, you will see it from one viewpoint. Your brain connects visual information, such as shadow and tone, and this helps you to see the object in three dimensions. If you observe what an object really looks like from different perspectives, you will have a much better understanding of its structure and form. What does it look like from the front, the back and from each side?

1. Take time to study your sculpture. Move around the form and observe how the contour and structure changes as you alter your position.

2. Use four different coloured felt-tip pens or markers.

3. Choose one of your pens and begin to draw the outline of the sculpture head-on. Follow the contours with your pen, letting your line respond to the sculpture.

4. Next, move around the sculpture by 90 degrees and make another drawing in another colour, over the top of your first image.

5. Move around another 90 degrees and make a new drawing using a different colour pen, overlapping the previous lines once again.

6. Repeat this until you have returned to your starting point. You should now have four layered drawings in four different colours, converging to form a pattern of intersecting lines. Where the lines fuse and intersect, you will see the sculpture appear in three dimensions.

Look up:

Georges Braque Cubist still lifes
David Hockney 'A Walk Around the Hotel Courtyard, Acatlan' and 'Joiners' photomontages

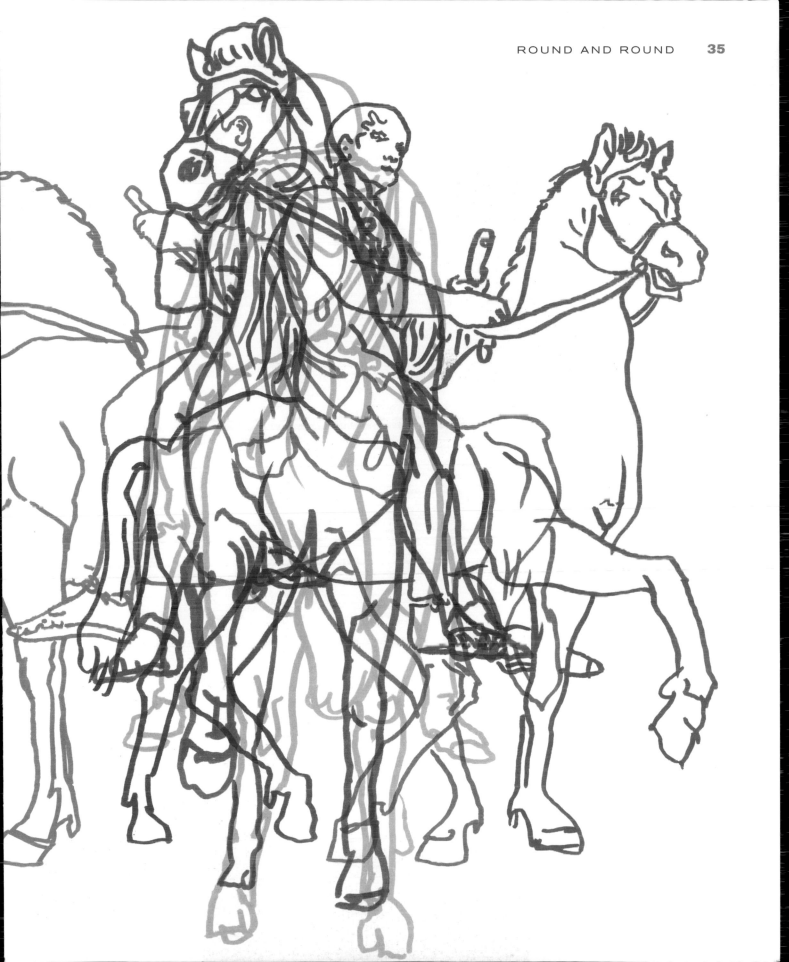

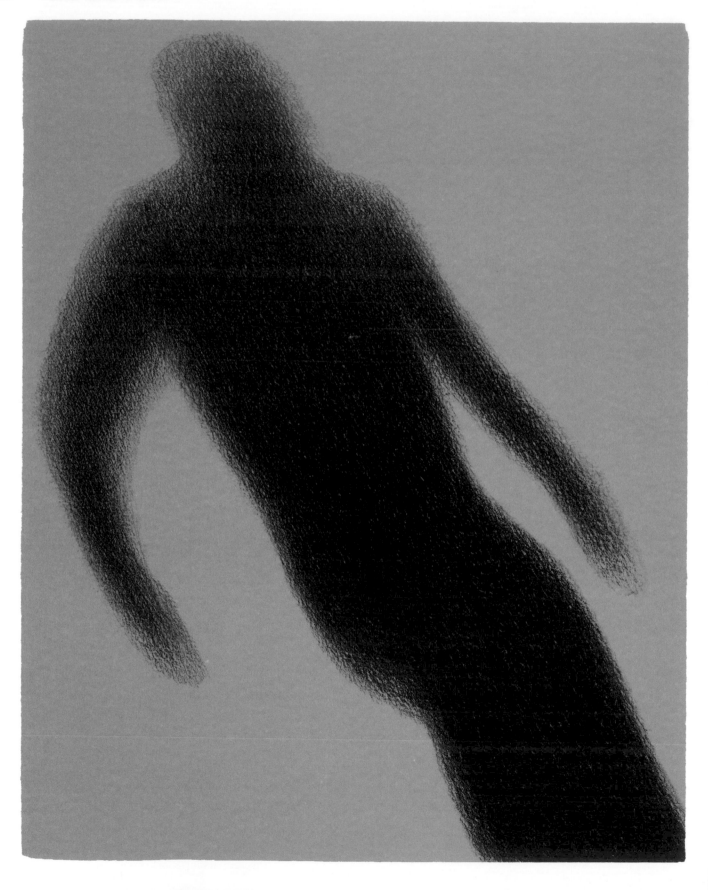

'Where there is much light, the shadow is deep.'

Johann Wolfgang von Goethe

Shadow Play

Shadows enliven and give depth to a drawing, creating a sense of volume and mass. There are two types of shadows – form and cast. The form shadow sits on the subject directly opposite where the light source is hitting it. The cast shadow is formed when the subject blocks out the light source. This shadow is generally much darker and falls onto a nearby surface.

You will only be drawing the cast shadow for this task. Look at the density of the shadow. Does it alter tonally? Look at the diversity of tones within the shadow itself. Sometimes shadows have a darker interior and they will often diffuse and become lighter at the edges.

Artists Shigeo Fukuda, Suo Wobster and Tim Noble have all created remarkable shadow sculptures out of everyday objects and detritus.

1. Root around in your recycling for cartons, cans, bits of cardboard, paper, tape or other rubbish. You will eventually use these objects to build a sculptural form.

2. You will also need an anglepoise lamp or a brilliant sunlit day to cast a shadow of the sculpture onto a white or light-coloured wall or a flat surface. The brighter and more powerful the light source, the more intense the shadow will be.

3. Start to assemble the sculpture by taping, gluing or even just placing your objects on top of each other. Making the sculpture in front of the light source will help you to shape the shadow as you work.

4. Don't worry if the sculpture looks scrappy or ugly, as this will not be included in your drawing.

5. The shadow itself doesn't have to resemble anything realistic and can be an interesting abstract shape. It's entirely up to you what form it takes.

6. Once you're happy with your shadow, take some grey paper and a 4B pencil or a charcoal pencil, and draw it. You can give depth to the dark shading by accenting it with lighter colours around the edges.

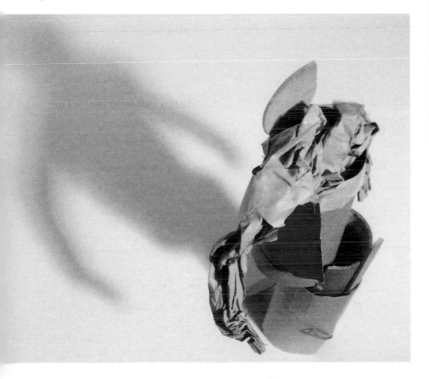

Square Eyes

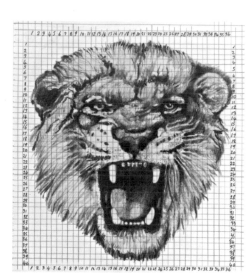

Use a hard pencil (H) and a softer touch to create the lighter tones. For the darker tones, use a softer pencil (B) and build up tone more intensely. Try hatching or cross-hatching to achieve the full range of tonal values.

This exercise is fairly labour intensive, but it will greatly strengthen your ability to recognise tonal gradation – it will show you how to dissect and reconstruct your subject matter into tonal values.

You will use the darkest tone with at least three 'bridging tones', through to white. It's also a good way to experiment with different shading techniques. Pencils have different tones, depending on whether they are soft or hard. For dark tones, use a very soft pencil and shade more vigorously. For the lighter tones, use a hard pencil and shade with a lighter touch. The drawing will take a while, but you can treat it like a jigsaw puzzle.

1. You will need the largest sheet of paper you can find, and a variety of pencils – charcoal and graphite, hard and soft.

2. Find a monochrome photograph with a range of tones, from black through varying greys to white. It can be anything you like – a portrait, an animal, a landscape or your favourite work of art. For this task, there should be no colour; keep it monochrome or greyscale.

3. Enlarge your image so that it fits comfortably onto a sheet of A4 paper and draw a grid over the top of it. The squares of the grid should be quite small, measuring approximately 5mm (¼in). Number the squares of the grid along the top and the bottom and down each side.

4. Now scale up your grid onto the large sheet of paper. Individual squares will measure at least 1.25cm (½in) – larger if you prefer. Number them in the same way as the small grid.

5. Look at your image and study each small square carefully. Try to find the dominant tone in each square and translate that tone into the corresponding square on the large sheet. Shade in the whole square with that tone only. Begin with the darkest toned square and find a tonal equivalent in terms of pencil softness. Use the appropriate pencil for each of the other dark tones.

6. Work your way through the tonal scale, continually scrutinising your original image for tonal matches.

7. For the lighter tones, use a hard pencil. Step back from the picture to see how the tonal groups relate to each other. Watch the image gradually emerge before you. You should end up with a pixellated, tonal equivalent of the original.

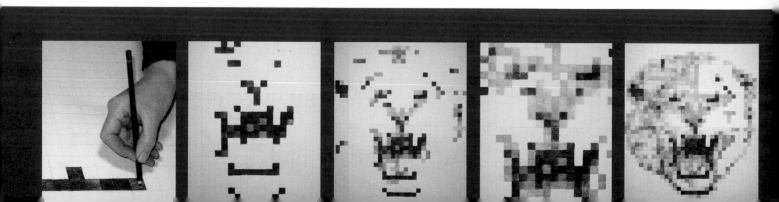

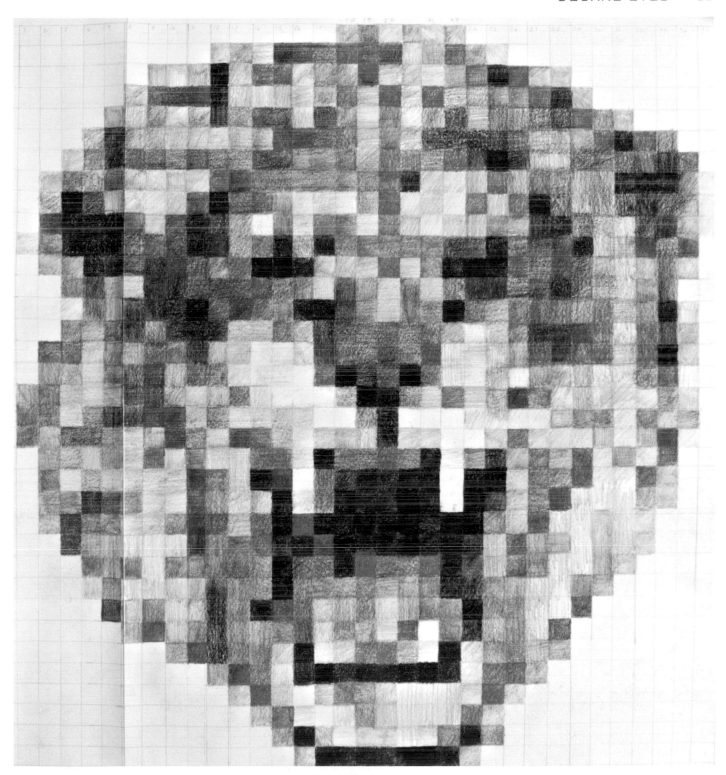

Look up:

Vik Muniz 'After Gerhard Richter [from Pictures of Colour]'
Chuck Close 'Self Portraits'

Que Seurat, Seurat

When Seurat first decided to become an artist, he spent an intensive two years studying drawing in black and white alone. He used very specific materials, including a black Conté crayon, which is slightly greasy when compared to charcoal and is easier to handle because it doesn't crumble. He also used Michallet paper, which was originally designed for the French neoclassical artist Ingres. Unfortunately, this paper is no longer produced, but its heavy texture gave Seurat the perfect surface on which to achieve his high-contrast images. Seurat greatly admired the masters of *chiaroscuro* (drawing with light and shade), such as Rembrandt and Goya.

The human face has a structure that reveals interesting contrasts when light falls on it. For this exercise, think of yourself as Georges Seurat, analysing a face in terms of light and dark.

1. You will need to use similar materials to those used by Seurat: a black Conté crayon and paper with a textured surface, perhaps even a heavyweight watercolour paper.

2. Seurat often drew by lamplight to enhance the dark shadows and strong highlights. Sit in a darkened space and use an anglepoise lamp, a torch or candlelight to create dramatic shadows on your own face, or a model's. Make sure you have enough light to comfortably draw by. Remember that you are looking for sharp contrasts of light and shade, with no mid-tones.

3. Begin to block in the areas of dark shadow, thinking of them in terms of positive and negative space.

4. Using the black crayon, shade in the darkest areas, perhaps within the eye sockets, under the chin, under the nose or on the side of the face that is away from the light source.

5. Be brave and don't include any of the finer facial details. An easy way to achieve this is to view the subject matter through squinted eyes. Squinting will accentuate the contrasts and eliminate the details.

6. Try not to overwork your image. It is really important to stop when the image has reached the right balance of light and dark.

Look up:

Georges Seurat 'Seated Boy with Straw Hat'
Rembrandt van Rijn 'Self Portrait'
Caravaggio 'The Lute Player'

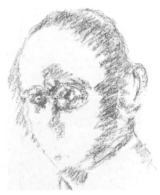

Pick out the darkest shadows around the eyes and head.

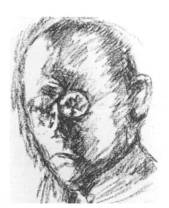

Darken the shadows along the nose and under the chin.

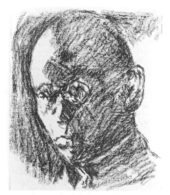

Build up the shading until the face is fully formed tonally.

Get to the Point

This exercise follows on from the previous task – you will be reproducing the same portrait in a different medium.

Seurat developed his neo-Impressionist painting technique, called pointillism, through his keen interest in studying colour theory. His paintings were made up of small dots of primary colours placed closely together. When seen from a distance, the coloured dots combine to create the illusion of light, shade and form. As you get closer to the canvas, the dots of pure colour become visible and the illusion is revealed. In this exercise, you aren't going to use colour; you are going to use dots in a more rudimentary way, to build up a sense of tone and form. The denser the dots, the more intense the darker areas will be. You will end up with an alternative version of your *chiaroscuro* portrait using a stippling technique. However, this is stippling with a difference.

Look up:

Georges Seurat Pointillist works
Paul Signac Pointillist works
Chuck Close 'Bill Clinton'
Lucio Fontana 'Spatial Concept' series
Damien Hirst 'Spot Paintings' series
Yayoi Kusama 'Dots Obsession'
Sigmar Polke 'Rasterbilder' series
Alain Jacquet 'Portrait d'Homme'
Roy Lichtenstein 'Reflections on Girl'

1. Find some thick cardboard to use as a support for your artwork. Then place a sheet of paper on top of it.

2. Fix the paper around the edges with masking tape.

3. Next, find something with a sharp point, perhaps a compass, large needle, awl or anything that will easily pierce the paper.

4. You are going to reproduce the portrait in dots, inspired by Seurat's technique.

5. Begin to pierce out the shapes of the dark shadow areas with your sharp implement. (This is a great way to relieve stress.)

6. Gently puncture the paper, piercing through to the cardboard layer underneath.

7. Build up a series of dots to create a repetitive structure of holes depicting the shaded areas of your image. However, don't get carried away, as the paper needs to remain in one piece.

See also: Que Seurat, Seurat, pages 40–41.

Tone, Tear, Stick

Thinking and seeing in black and white, and all the tones in between, can be tricky. Using this method, you can only work in broad areas of tone, as you are limited by how small and how accurately you can tear the paper. So, unlike working with pencil, when linear detail might creep in, this exercise ensures that you are focusing on seeing and analysing broad areas of different tone.

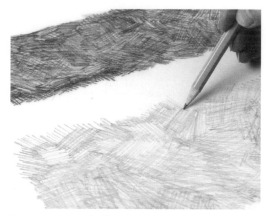

Prepare areas of different tones.

Tracing paper has its own subtle tone.

Light tone hatched with a 2H pencil.

Mid-tone cross-hatched with an HB pencil.

Layering can modify the value of each tone.

Dark tone cross-hatched with a 2B pencil.

1. Use a colour image from your collection, or a magazine or book. Choose something that is not too detailed.

2. Select two or three grades of pencil, such as 2H, HB and 2B. You can use either white paper or tracing paper (the tone of the tracing paper gives you another pale tone to work with). Build up three or four large areas of different tones by hatching and cross-hatching with the various pencils.

3. On a separate piece of paper, roughly sketch the basic shape of the image you want to re-create (or you could live dangerously and work without any guiding lines).

4. Look at the reference picture, and from the palest prepared tone, tear one or two overall shapes to form the image and stick them onto your paper. You could tear out some smaller shapes within the tones before you stick them down so that the white paper will show through and create highlights.

5. Gradually build up the image by tearing out the shapes from your prepared blocks of tone and sticking them down, matching the dark, light and mid-tones with those in the image.

6. If you are working with tracing paper, you have the added effect of slight transparency between the layers, which can help to subtly darken some of the highlights, or conversely to lighten some of the darker tones.

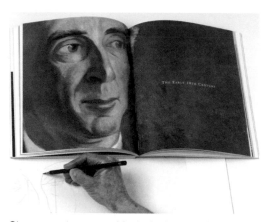

Choose an image and loosely draw guide shapes.

Tear out the shapes of the tones as you see them.

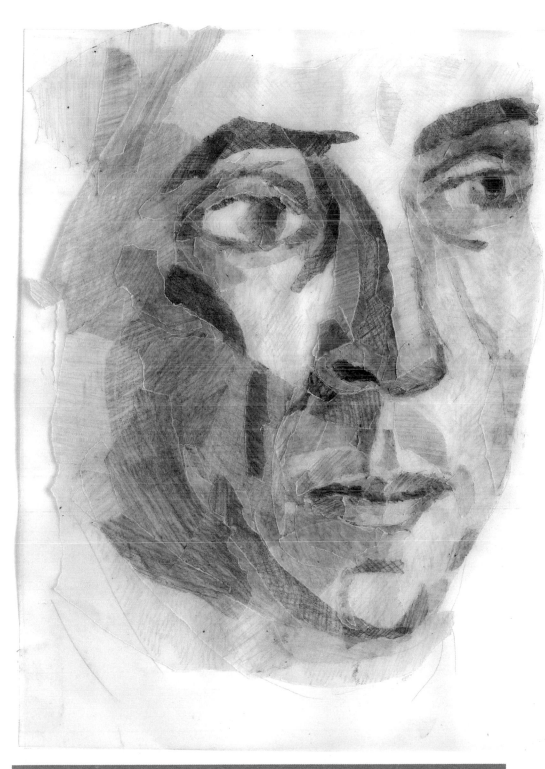

When working with tracing paper, it is very easy to modify the tones as you work by simply adding more layers. You can tear the paper so the directional lines of the pencil explain the shape. In this example, the paper pieces have been torn so that the pencil hatching forms the curve of the jaw-line.

Look Up

Henri Matisse 'Icarus' from 'Jazz'
Kurt Schwitters 'Pino Antoni'
Pablo Picasso 'Guitar' collages
Georges Braque 'Newspaper, Bottle, Packet of Tobacco'

Whiter Shade of Pale

'I conquered the lining of the colour of the sky and tore it off, put the colour into the resulting bag and tied a knot. Fly! A white hue of endless infinity is before you.'

Kazimir Malevich

Kazimir Malevich's 'White on White' Suprematist painting was completed in 1918, only one year after the Russian Revolution. His intention was to construct a new form of artistic expression by pushing the boundaries of abstraction as far as possible. He painted a white rectangular form, at an angle, on a slightly warmer background. By minimising colour, he focused on the subtle tones and the surface area of the canvas. He used white as a metaphor to express the infinity of the universe itself. The American pop artist Jasper Johns also decided to push the idea of minimalism to its limit. His 'White Flag' painting depicts the American flag in monochrome. By reducing it to a subtle white palette, we no longer see the flag as an iconic symbol but instead become aware of the fabric and structure of the painting itself. Similarly, if we narrow down our tonal palette, we become aware of the surface textures and patterns, and can concentrate on the drawing process itself. This exercise focuses on minimising tones and reducing the visual palette to highlight the simplicity of form.

Use two L-shaped pieces of card as a viewfinder. They form a frame you can slide around until you find the composition you like.

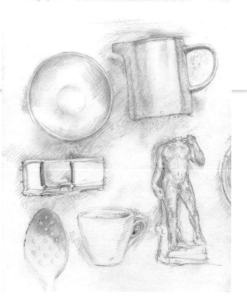

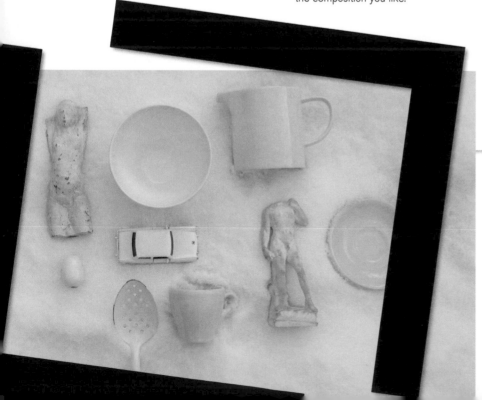

Look up:

Kazimir Malevich 'White on White'
Ed Ruscha 'Miracles' series
Jasper Johns 'White Flag'

1. Lay out a selection of white objects on a white background.

2. Use a viewfinder or a frame to home in on your setup.

3. Compose your image within this frame. Look closely at your objects and consider their shapes and forms.

4. Use faint outlines to delineate the objects. Begin with the light areas first and gradually build up the darker tones.

5. Use light, hatching and cross-hatching techniques to describe the form. Pick out the subtleties and try to evoke a mood in tone.

See also: Still Life, pages 54–57.

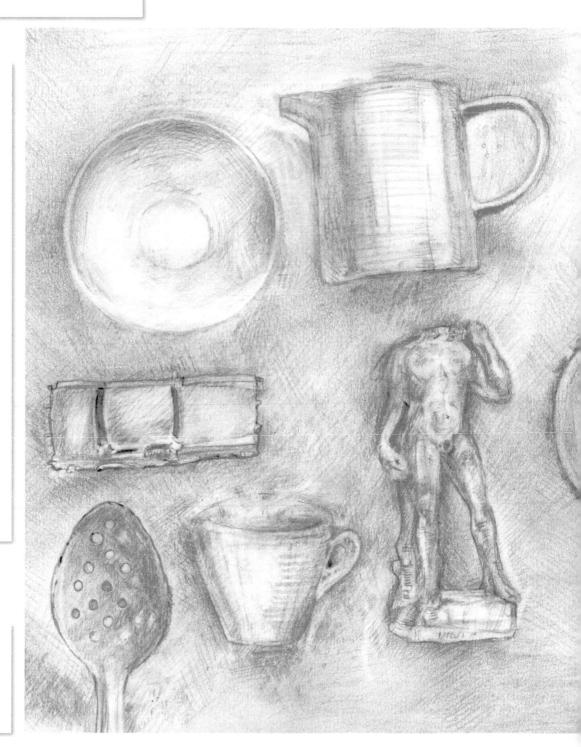

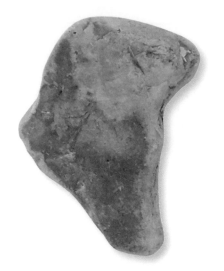
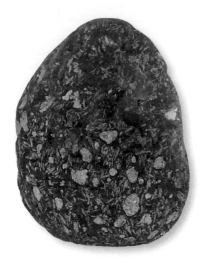

No Stone Unturned

Take a close look at form and texture by finding some stones and drawing them.

Many artists are big fans of stones and pebbles. Look at a pebble closely and you will see a mini work of art. Try to recapture these subtle markings in a series of drawings. In fact, the monumental sculptures of British artist Henry Moore are inspired by these natural forms. 'I have always paid great attention to natural forms, such as bones, shells and pebbles,' he said in a recorded interview in 1937. 'Sometimes for several years running I have been to the same part of the seashore – but each year a new shape of pebble has caught my eye, which the year before, though it was there in hundreds, I never saw. Pebbles show nature's way of working stone.'

Look up:

Henry Moore Sculptural drawings
Jim Ede An Arrangement of Pebbles in the Shape of a Mandala at Kettle's Yard, Cambridge

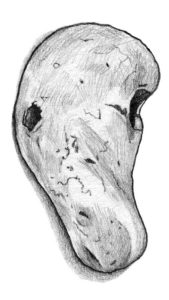
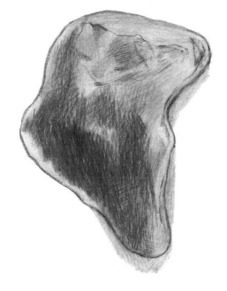

2B pencil

Coloured pencil

Fine felt-tip

1. Go out for a walk and collect some stones or pebbles of varying shapes and sizes.

2. Look closely at the shape of every stone that you collect and draw them. Look for stones that have strong 'personalities' or interesting characteristics.

3. Think about the outside edges and the outline they create. Consider the arrangement of shapes and forms on the surface of each stone.

4. Try to describe both the form and texture of each pebble, using a range of different tonal values.

5. Look at the shadows and highlights. From which direction is the light falling?

6. You can use directional lines or cross-hatching. Or you may choose to work in negative, erasing areas of tone to create highlights.

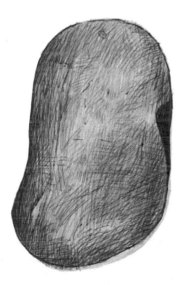
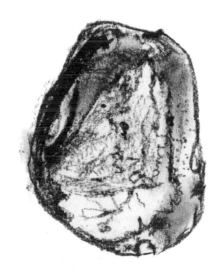
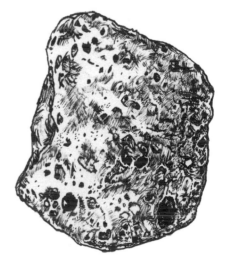

Coloured pencil

Charcoal

Pen and ink

Hot Chocolate

Everywhere you look you can see examples of form. The Modernist architect Le Corbusier saw everything in terms of cubes, cones, spheres, cylinders or pyramids, and he suggested that light and shade helped unearth the beauty of each form. To understand how to draw objects within their surroundings, we have to observe the different forms we see around us.

For those of you with a bit of a sweet tooth, this task is a great excuse to indulge yourself.

Treat yourself to a box of chocolates, open up the box and place each of the chocolates in front of you. Select a fairly large sheet of paper, on which you are going to draw the assortment of chocolates.

1. For this drawing you will need a selection of coloured pencils (mostly earth tones).

2. Study the different forms that you see. You should have an assortment of shapes, colours and tones. Tone helps to create a sense of volume and three-dimensional space.

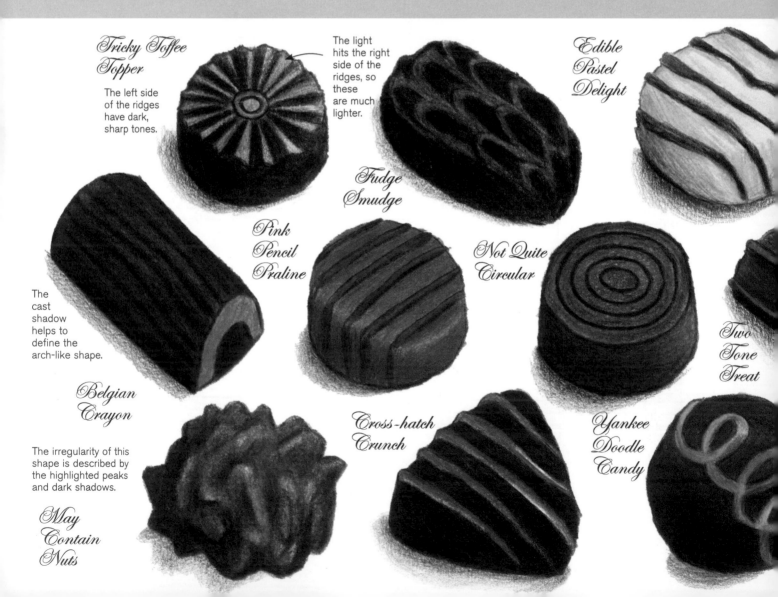

Tricky Toffee Topper

The left side of the ridges have dark, sharp tones.

The light hits the right side of the ridges, so these are much lighter.

Edible Pastel Delight

Fudge Smudge

Pink Pencil Praline

Not Quite Circular

The cast shadow helps to define the arch-like shape.

Belgian Crayon

Two Tone Treat

The irregularity of this shape is described by the highlighted peaks and dark shadows.

May Contain Nuts

Cross-hatch Crunch

Yankee Doodle Candy

3. Introduce colour to differentiate each chocolate. Although most chocolates are brown, there are differing hues, shades and tones of brown. Adding blue tones to the shadows will enhance the form and help to give the illusion of volume.

4. Look closely at each chocolate and observe where the light and shade is falling on the form. Gradate the tones from light to dark, creating solidity with light and shade.

Is the light source hitting each chocolate in a different way?
• If the form is a cube (as in the Cubist Caramel), the light will fall directly on one side and the darker side will be opposite that.
• If the chocolate is a cylinder (like the Belgian Crayon), the light will gradually blend around the form.
• A spherical form (such as Pink Pencil Melt) will reveal an even gradation of tones from dark to light. There may also be a highlight where the light source hits the sphere.
• Is there any reflected light? If the

chocolates are on a light background, there will be a light reflection from the surface that falls on the underside of the chocolates. Reflected light will make the dark side appear lighter.

5. Now put down your pencils and give in to the temptation.

Look up:

Le Corbusier *Vers une Architecture [Towards a New Architecture]*

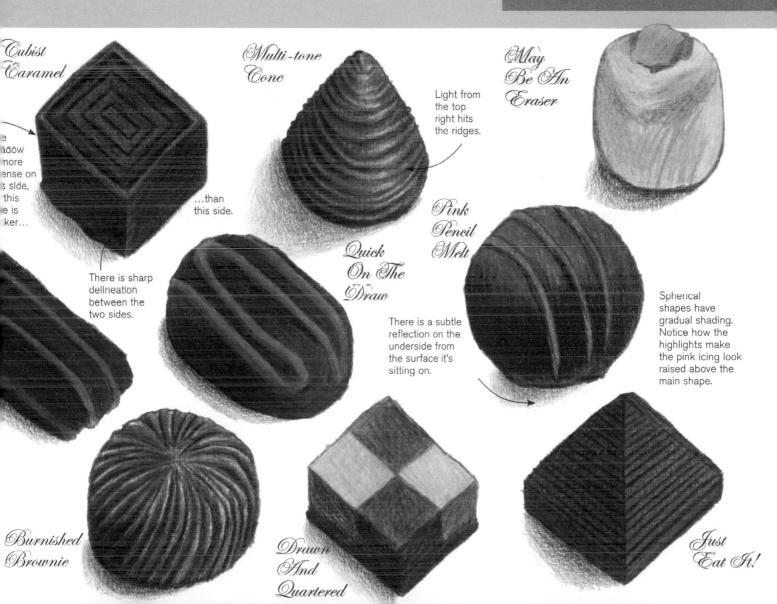

Cubist Caramel

...adow more ense on s side, this e is ker...

There is sharp delineation between the two sides.

Multi-tone Cone

Light from the top right hits the ridges.

...than this side.

Quick On The Draw

There is a subtle reflection on the underside from the surface it's sitting on.

May Be An Eraser

Pink Pencil Melt

Spherical shapes have gradual shading. Notice how the highlights make the pink icing look raised above the main shape.

Burnished Brownie

Drawn And Quartered

Just Eat It!

Can Crusher

You are going to study a simple form undergoing a series of physical changes.

Pop artist Jasper Johns was renowned for his studies of everyday objects. He chose to depict the humble beer can and made sculptures of it. He devised a subtle narrative, in two stages – the first can unopened and the second empty.

Your everyday object will be a fizzy drink can. You are going to make three drawings that document a can being gradually crushed. You will observe how its tone and shape mutates – a transmogrification of structure and form. When you compare the drawings, in sequence, it will give you an understanding of the nature of form.

1. Take a fizzy drink can from the fridge.

2. Use a number of pencils, both hard and soft.

3. Place the can upright on a white sheet of paper.

4. First, sketch the outline of the can, drawing the curved ellipses at the top and bottom. The cylindrical form will start to take shape.

Look up:

Jasper Johns 'Ale Cans'
Andy Warhol 'Campbell's Soup Cans'
Hasegawa Yoshio 'Catch the Zero'
John Chamberlain 'Ultima Thule'

The cylindrical form is suggested by shading and by the curve of the marks made.

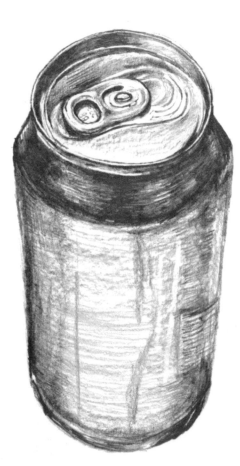

5. Next, disregard the graphics on the can and describe the cylinder in terms of tonal gradations, paying careful attention to the shading. If you have a single light source, you should have a lighter area on one side graduating to darker shades on the other.

6. After finishing the first drawing, take a break and drink the contents of the can.

7. Once the can is empty, gently crush it in your hand and look at how the structure has changed. You will notice how the crushed sharp edges are modelled with reflected light and shade. As its solidity alters, you will be aware of its weight and mass collapsing. Begin to draw the new shape and once again describe it in terms of tone.

8. For the final drawing, stamp on the can so that it is completely flattened and its structure is completely compressed. Draw the squashed can, observing the compact pattern of tones and modified shapes.

9. Look at the drawings in sequence and study the metamorphosis of the form.

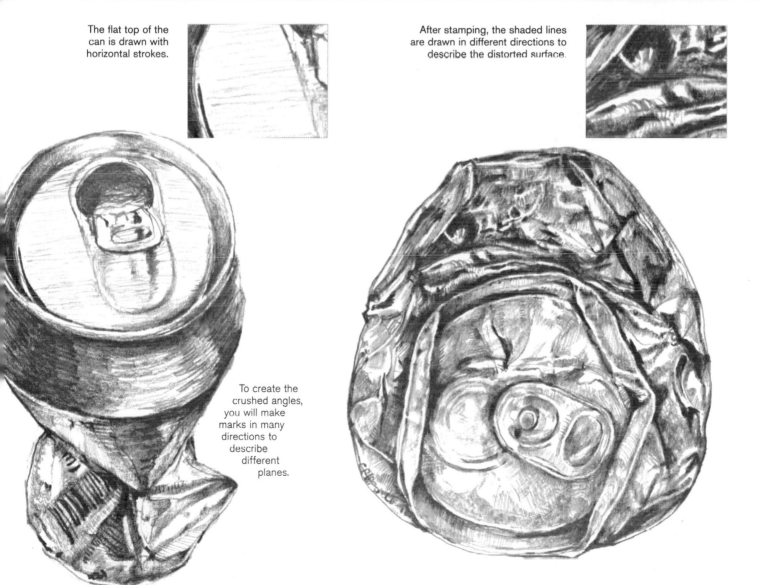

The flat top of the can is drawn with horizontal strokes.

After stamping, the shaded lines are drawn in different directions to describe the distorted surface.

To create the crushed angles, you will make marks in many directions to describe different planes.

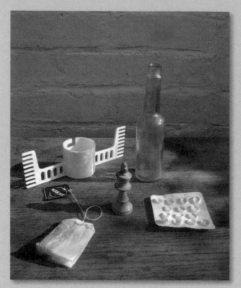

The objects have been arranged in an aesthetically pleasing composition. The dramatic lighting helps to define the forms and create mood.

Here we begin to position and delineate the individual forms by blocking in the shadows with a dark pastel.

The lighter areas are highlighted with a white pastel and the background and teabag label are defined with colour.

Still Life

Artists have grouped objects together to paint and draw them for thousands of years.

The Ancient Egyptians painted food and objects as gifts for their gods. Greek and Roman artists depicted grouped objects on vases and in mosaics. Still life painting in Flanders and the Netherlands in the sixteenth and seventeenth centuries focused on allegorical representations called vanitas, which included photorealistic images such as skulls, candles, hourglasses and decaying fruit. These symbolic metaphors served to remind the viewer that death is ever present. In the nineteenth century, artists such as Cézanne and van Gogh began to see still lifes as a series of interrelated shapes and forms. Cézanne would set up fairly elaborate compositions – often fruit, bowls, vessels and plaster casts. His compositions focused on scale and space.

Giorgio Morandi also looked at still life objects as if they were pure structures. Using a minimal range of colours, his intense observational works were restrained and contemplative. He chose to depict unremarkable and extremely familiar forms, and positioned his objects with precision. He arranged them in such a way as to create a sense of tranquility and simplicity. Wolfgang Tillmans' still life photographs have updated the simplicity and reductive qualities of Morandi's work. He likewise focused on the relationship between objects, and chose to portray banal and everyday forms.

For this task, focus on the simplicity of the forms. Arrange your own still life using a collection of kitchen utensils, ornaments or anything that you feel will work together.

See also: Whiter Shade of Pale, pages 46–47, and Decompose, pages 118–119.

1. Find a number of unremarkable and everyday objects and arrange them on a table as a still life. They don't have to be very interesting or aesthetically pleasing.

2. Look at each object individually and assess the relationship the object has with the others.

3. Place them on a table, shelf or windowsill.

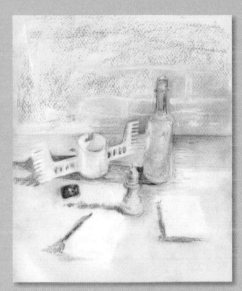

The bottle and plastic whisk are formed by adding tone and colour. The chess piece is picked out using a mid-tone pastel.

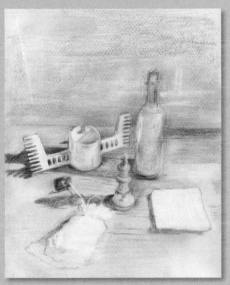

Here the shadows are gradually built up. Notice how the cast shadow of the bottle depicts the colour of the reflected light.

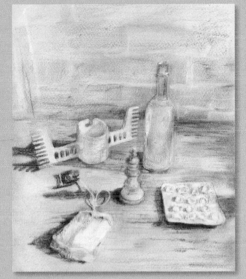

Details are added to the plastic pill packet and teabag. More definition is given to the brickwork in the background areas.

4. Consider the spaces within and around the objects.

5. Now think about where the light is falling on your forms and consider where the shadows are cast on each object. Is your still life sunlit or does it have more subdued lighting?

6. Look carefully at the tonality, shape and volume of your objects.

7. Begin to draw once you are happy with the arrangement. To create a sense of atmosphere and contrast, the background and foreground areas are darkened and the objects are further refined with touches of colour and tone.

Continued on the next page

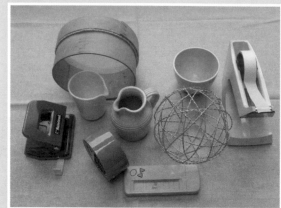

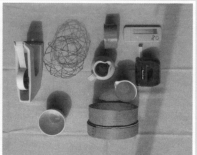

With a still life, you are master of the composition and viewpoint. Take some chosen objects and photograph them from each side, from above and from a three-quarter angle. The lighting can be strong, dynamic sunlight or soft, subtle shadows.

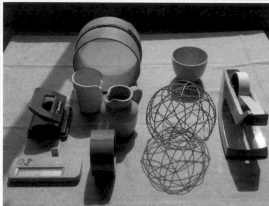

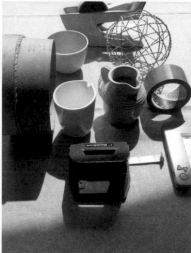

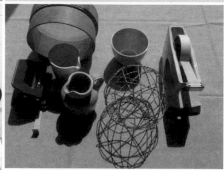

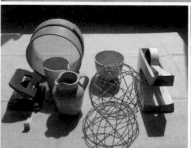

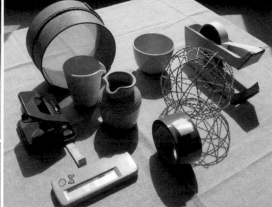

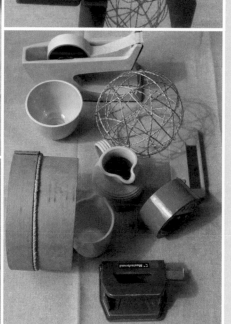

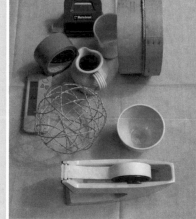

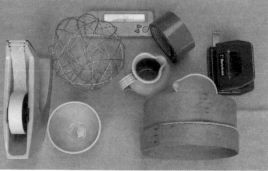

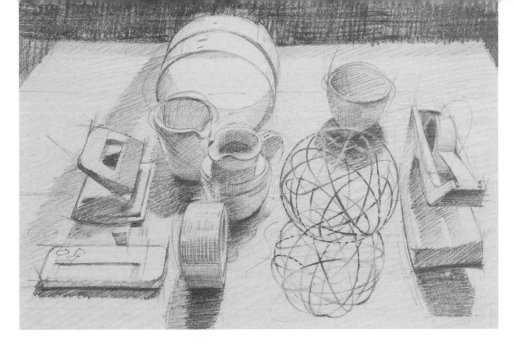

Choose different viewpoints and make some drawings of your objects (above and below). You could draw one with dynamic shadows and another with soft shadows, or with added colour. As you draw, notice the difference the viewpoint, and light and shade, make to the shape and form of the objects – think about how you can express this tonally. Cast shadows add depth and dynamism to the composition. You can use a variety of pencil grades or coloured pencils to create a sense of atmosphere and contrast.

Look up:

Giorgio Morandi Still Life paintings including 'Still Life Painting with Bottles and Boxes' (below)
Paul Cézanne 'Still Life with Skull'
James Ensor 'Still Life with Skate'
Damien Hirst 'The Physical Impossibility of Death in the Mind of Someone Living'
Wolfgang Tillmans Still Life photographs
Sam Taylor-Wood 'Still Life'

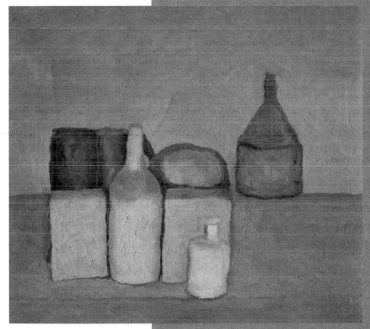

Your still life can be refined with touches of colour and tone. A sense of atmosphere has been created in this piece by Giorgio Morandi despite the simple and generic choice of subject matter.

Feel the Darkness

Chiaroscuro **is an Italian word that means 'light–dark', and gives its name to a method employed by artists in which they use strong light and dark contrasts to give the illusion of a three-dimensional form.**

Rembrandt was a master of *chiaroscuro*. He was celebrated for the dramatic play of light on the subjects of his paintings and drawings. His dark, and often gloomy, paintings, including many self-portraits, revealed a masterful appreciation of light and shade.

'The Night Watch' is one such painting. Rembrandt's huge canvas depicts a military unit with Captain Cocq as a central character, his lieutenant by his side, and a young girl mascot at his rear. Rembrandt draws attention to these characters by illuminating each subject individually. The lighting creates a powerful sense of tension and drama. It is almost as though he was painting with light itself.

Here we are going to take darkness to an extreme. This will help you grasp the power of light and shade when you are creating form.

Look up:

Rembrandt van Rijn 'The Night Watch'
Francisco Goya 'The Fantasies',
 'The Disasters of War' and 'The Follies' series
Caravaggio 'Salome Receives the Head
 of John the Baptist'
Francis Bacon 'Head VI'
Odilion Redon 'The Teeth'
Kathé Kollwitz 'Battlefield'

The entire page is covered in pitch black charcoal.

1. Cover a large sheet of paper in your sketchbook with charcoal or graphite until it is black.

2. Now wait for nightfall and then close the drapes, shutting out any extraneous light. Have your large sketchbook and a putty eraser close at hand.

3. As your eyes start to adjust to the darkness, try to decipher the shapes and forms that begin to appear.

4. Decode as much as possible and translate onto the page what you can see emerging from the shadows.

5. Use your putty eraser to remove the darkness, to highlight the image materialising in front of you.

6. Think about the negative and positive spaces and draw in light.

7. Get grubby, smudge, blend, rub into, lift off, erase and pick out the highlights. You are now working in negative. Instead of applying tone, you are erasing it.

As the eraser reveals all (right), many more details start to appear: the reflection in the mirror, the highlights on the radiator and an LED clock can be seen.

The subtle highlights begin to trace out the objects in the room: the chair, curtains and radiator.

More and more of the scene is emerging. The floorboards and a pair of shoes appear in the foreground.

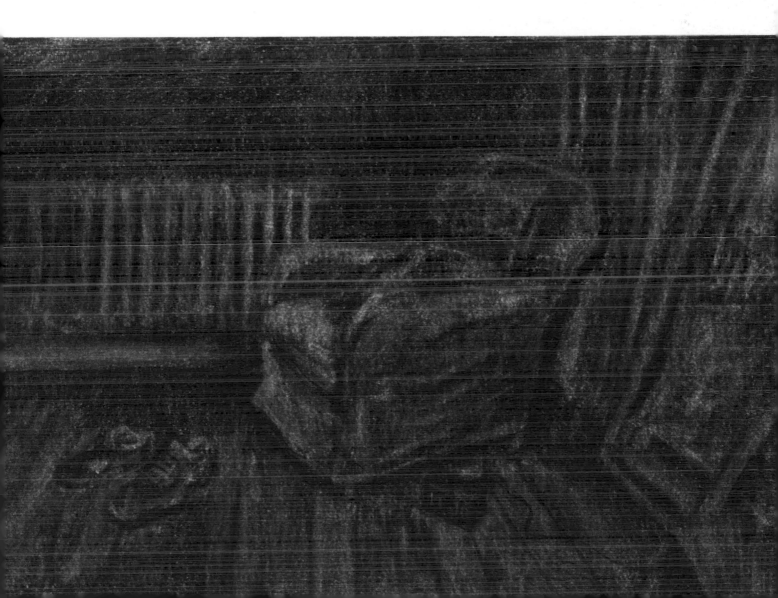

CHAPTER

3

In this chapter, we will focus on developing an awareness of space. We will discover how we can observe and represent our world objectively, from many different viewpoints. The exercises included here will help you to find ways of representing three-dimensional space on a flat picture plane, and you will explore the decision-making processes involved in creating a strong composition.

Composition, Perspective and Viewpoint

'You become aware that there are different forms of realism and that some are more real than others.'
David Hockney

Ghérasim Luca, a member of the Surrealist group, devised a collage technique that he termed 'cubomania'. This involved drawing a grid of squares over an image, then cutting out the squares and randomly reassembling them in a completely new order.

Cubomania

By subverting and cutting up the image, Luca believed that you become less precious about the original. The picture no longer has a visual order, and our senses are confused. This chaos and disorder forces us to look closer at the abstract shapes and patterns, and the image takes on a whole new meaning. Since the 1400s artists have been using grid systems to re-create accurate compositions of what they were observing. Albrecht Dürer made an etching of the Italian masters using such a system. Luca's technique turns this on its head. The traditional rules of composition no longer apply.

For this exercise, you are going to take on board Luca's radical directives. You are going to rearrange and rejig, disrupt and disturb.

This drawing was produced using a coloured photograph, a collection of paintbrush textures and a monotone pencil drawing. The background image and textures were scanned onto a computer and combined to produce the final image.

> **See also:** Rule of Thirds, pages 68–69.

1. Make a square drawing with a number of different materials. Your picture should have contrast in tone and shade and texture.

2. Cut up the image into equal squares (a minimum of nine), then rotate and place them so that the original image is indecipherable.

3. Now stick these segments down.

Look up:

Ghérasim Luca 'Portrait of Elizabethe of Austria' and 'Indochina'
Tristan Tzara Symbolist poetry
Tom Phillips 'A Humument: A Treated Victorian Novel'
Albrecht Dürer 'Draughtsman Making a Perspective Drawing of a Woman'
Kurt Schwitters Photo collages
Hannah Höch 'Cut with the Kitchen Knife'

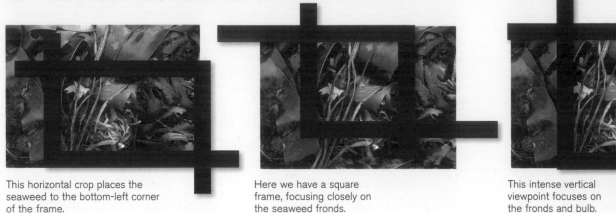

This horizontal crop places the seaweed to the bottom-left corner of the frame.

Here we have a square frame, focusing closely on the seaweed fronds.

This intense vertical viewpoint focuses on the fronds and bulb.

Crop

One way to improve your drawing is to pay careful attention to framing. Essentially, it's about striving for a balance of compositional elements.

Before you put pencil to paper, you need to focus on exactly what you see before you. Make sure that everything within your composition is there because you want it to be there. Be brave, and don't be scared to crop right into the image if necessary. By homing in on your subject, you can sometimes make your composition more dynamic. Editing is an important part of composition.

1. Cut out two L-shaped pieces of card and place them on top of each other to use as a viewfinder.

2. Now find a visually interesting object – this can be anything from a shoe to a car. Move around your object and adjust the viewfinder to frame it in different ways.

3. Decide exactly what it is that you want to say about your object and try to convey that message through your crop.

4. Look for focal points within the composition that lead the eye into the image. Take into account the negative and positive space. Also consider the scale, tones and contrast of your subject.

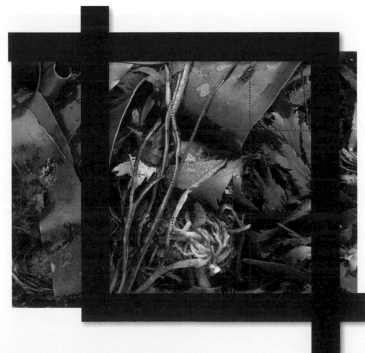

The chosen crop. See how the 'Rule of Thirds' principle can be applied to the image: the strong vertical fronds lie within the left-hand vertical third and the focal point of the seaweed blub is positioned in the central bottom third.

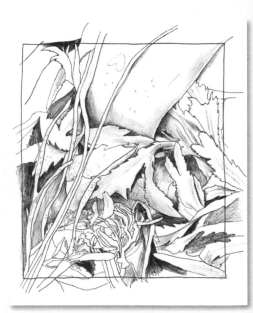

Outline the essential contours with a pencil.

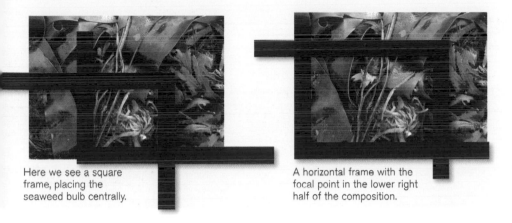

Here we see a square frame, placing the seaweed bulb centrally.

A horizontal frame with the focal point in the lower right half of the composition.

Look up:

Henri Cartier-Bresson 'Behind the Gare Saint-Lazare'
Edgar Degas 'Two Dancers on a Stage'
Man Ray 'Larmes Tears' and 'Kiss'

5. Think about the angle and dimensions of your crop. Would it look better vertical or horizontal?

6. Consider compositional rules such as the 'Rule of Thirds' and the 'Golden Section' (see pages 68–69) but don't be a slave to their conventions. There are no hard-and-fast rules. Remember that it is all about what you feel you want to convey. You will discover that, by focusing on the important elements within a picture, you can change the tension, dynamism and sometimes even the meaning of an image.

7. When you have settled on a composition that you are happy with, start drawing.

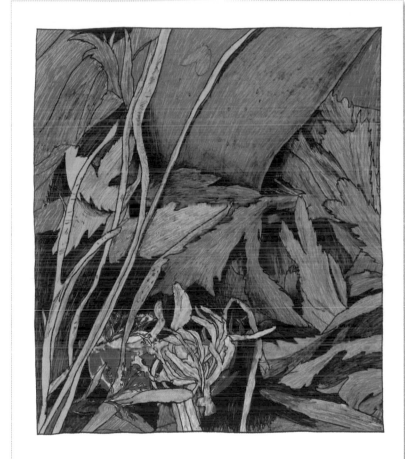

Finish off with more intense colouring to reveal a keenly observed representation of the original crop.

See also: Rule of Thirds, pages 68–69.

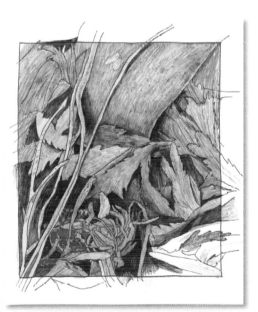

Begin to apply tone and colour to your image.

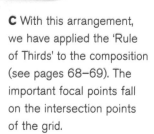

Desert Island Things

You are about to be cast adrift on a desert island and are only allowed to take with you three of your most precious belongings. Think about what things are really special to you; the possessions that define who you are.

Some things are precious because they have been handed down through generations, while others may hold an emotional attachment for you alone – they could be anything from a favourite book to your childhood teddy bear. Draw a composition of your three most treasured possessions on a very large sheet of paper.

The 'Rule of Odds' is a compositional term that refers to a visually pleasing arrangement of an odd number of objects. An example of this is Antonio Canova's 'The Three Graces'. It is sometimes possible to make an image more visually exciting by grouping an odd number of objects together – a composition of three, five or seven, for instance, instead of two, four or six. Grouping an odd number of things together can make it hard for the eye to pair them up, resulting in a pleasing visual tension. Placing elements together in pairs gives a sense of symmetry but a grouping of odd numbers often creates more interest and harmony.

A

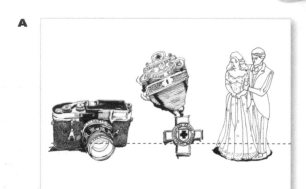

B

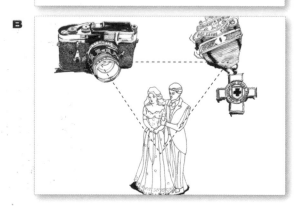

A Each item is evenly placed on a horizontal plane, with equal weight and importance.

B The objects are positioned within a triangular composition. Once again they are given equal weight and significance.

C With this arrangement, we have applied the 'Rule of Thirds' to the composition (see pages 68–69). The important focal points fall on the intersection points of the grid.

D Experiment with scale, altering the size and hierarchy of each element. Here, the medal is larger and more prominent and the wedding couple and camera are smaller and less dominant. The composition leads the eye from one element to another.

E It can be visually exciting to crop into your image and to focus on certain elements. Here the camera has been given more weight and is heavily cropped. The camera lens and the wedding cake figures all face out of the frame, guiding our viewpoint in different directions.

F You can aways use a vertical/portrait format. You may choose to overlap your drawings to find the best arrangement.

Look up:

Antonio Canova 'The Three Graces'
Michael Landy 'Breakdown'
Sandro Botticelli 'Primavera'

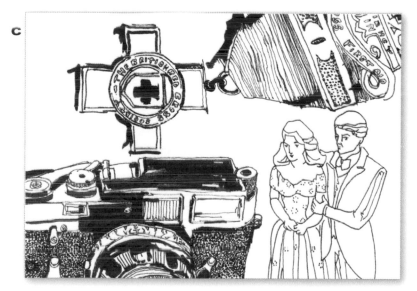

C

D

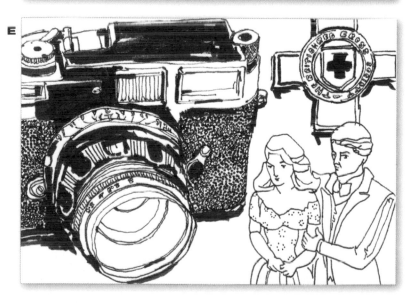

E

1. Consider the placement of every object on your page. They might be aligned or within a triangle.

2. Draw each object separately on the page and think about the overall framework. The three elements should work together as a unified composition. Refer to the 'Rule of Odds'.

3. Consider the form and character of each of your objects. Alter the proportions and scale if necessary to create a cohesive image.

4. When you are planning the whole composition, keep in mind the balance of elements; there should be a hierarchy of heights, textures and shapes.

F

Rule of Thirds

The 'Rule of Thirds' is a compositional device that involves superimposing a grid on an image and dividing the canvas equally into thirds, both vertically and horizontally. The intersections of the grid lines create focal points of interest. Placing certain visual details at the focal points helps to draw attention to them. They create areas of emphasis within the framework that balance with the remaining 'quiet' areas.

There are certain sets of guidelines used by artists and designers to aid composition. The 'Golden Section', for example, is based on a numerical principle where a rectangle is divided so that the ratio of its shorter side to its larger side is approximately 0.618. The ancient Greeks believed that this calculation could be used to attain ideal proportions. During the Renaissance, artists adopted it as a compositional tool and Leonardo da Vinci's 'Vitruvian Man' illustrates the principle perfectly.

The 'Rule of Thirds' is similar to the 'Golden Section', but the image is divided into thirds equally and the intersection points meet closer together. It is a compositional principle intended, in general, to create a sense of balance and harmony. Your composition should, however, reflect a personal intention – you should, wherever possible, use your intuition to determine how you apply these rules. They are only guidelines, and your final decision really depends on your own unique viewpoint.

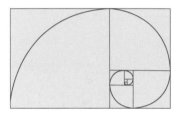

Here the 'Golden Section' ratio is applied: approximately 1 : 1.618.

The 'Rule of Thirds' is applied by dividing the height and width of the frame into thirds equally.

1. Go out for a walk and find a landscape or a cityscape that interests you.

2. Look closely at the subject matter and draw it, applying the 'Rule of Thirds' to make your composition.

3. Remember to consider elements such as colour, tone and dominant and subordinate areas in your composition.

4. Have an open mind and try out different arrangements.

5. Move your viewpoint around and find how the dynamics of the scene change. You can create tension and excitement by breaking the rules. Use them as a yardstick and as a starting point from which to experiment and explore.

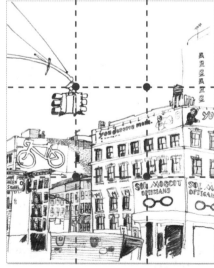

Look up:

John Thomas Smith Definition of the compositional 'Rule of Thirds' in *Remarks on Rural Society*

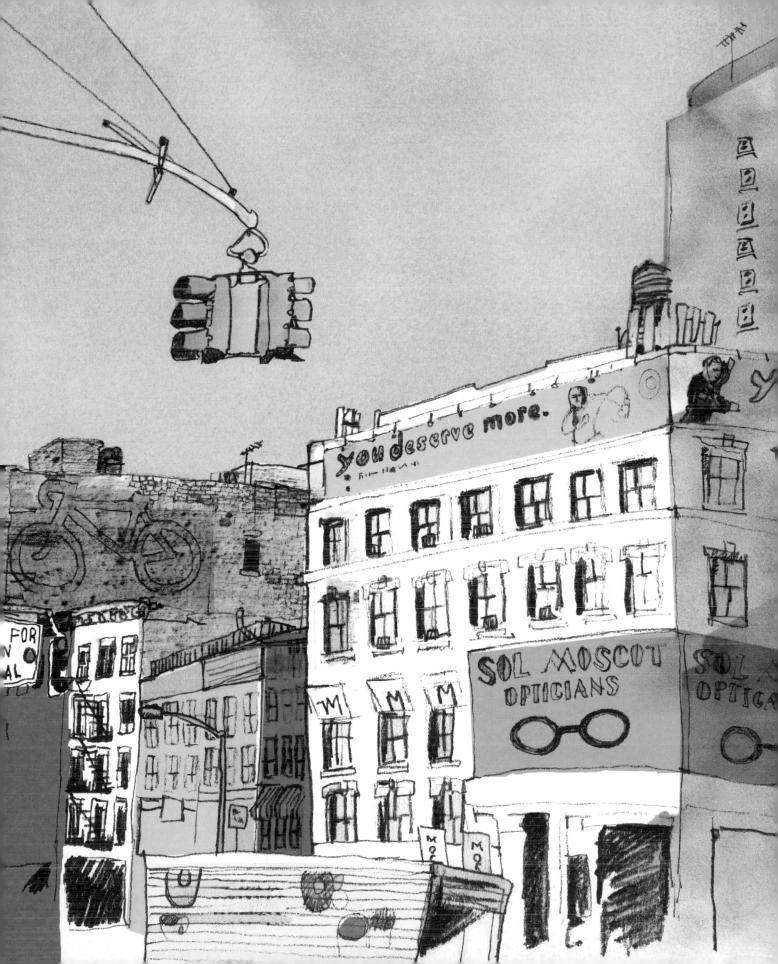

Zen Portrait

Zen sumi-e artists use black ink and a horsehair brush to draw directly onto paper or silk. With a masterful control of line and composition, they scrutinise their subjects at length. Whether it be a bird, a stick of bamboo, a landscape, an orchid or even a goat, they wait for just the right moment to apply ink to paper. Their aim is to capture the true essence of their subjects with a few decisive brushstrokes.

You are going to draw a portrait; and as you do this, you are going to think about the proportions of the face and make a mental grid to help you to organise and compose the features within it.

COMPOSING YOUR FEATURES

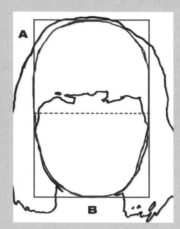 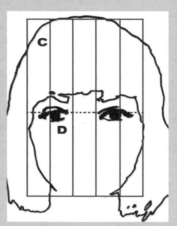 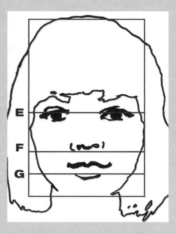 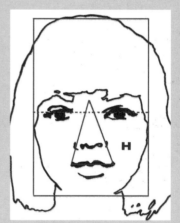

A Think of a rectangle that is roughly 2:3 in width:height ratio.

B Think of an oval shape with its narrow point towards the bottom. Fit the oval within the rectangle.

C Next, divide the rectangle vertically into fifths. This will help you to scale and place the eyes.

D The eyes sit within each fifth, on either side of the nose. They are symmetrically placed on the first horizontal line.

E Divide the rectangle in half with a horizontal line.

F Next, divide the lower section in half again.

G Finally, divide the bottom section in half. These horizontal lines are a rough guide to help you to position the features within the face. The eyes fall on the first horizontal line and the nose rests on the next line. The mouth sits on the bottom line.

H Finally, think of a triangle beginning at the centre point of the head and falling on either side of the nose. This will give you an approximate guide to the width of the mouth.

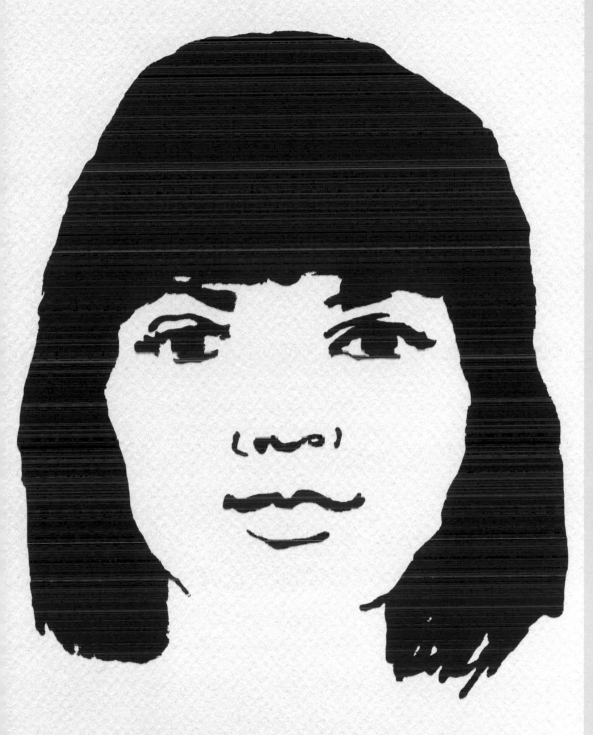

1. Find a willing model. If nobody is available, you can set up a mirror and use your own face as a subject.

2. Use some Indian ink and a medium brush. It doesn't have to be horsehair; you can use a synthetic brush. Use a sheet of heavyweight paper such as watercolour paper. Get the materials ready but don't start making marks yet.

3. When you have fully considered the guidelines (see panel opposite), concentrate on the intrinsic qualities of the face. Look at the individual features – the eyes, nose and mouth – and then think of them in relationship to each other. Just look and think.

4. After studying your subject for at least 15 minutes, wait for your own decisive moment and only then apply ink to paper. Having taken into consideration the basic proportions and individual character of your model, try to capture the true essence of the face with a few simple brush marks.

Look up:

Sumi-e artists who used this approach: Fugai Ekun (1568–1664), Sesshu Toyo (1420–1506) and Sesson Shukei (1504–1589).

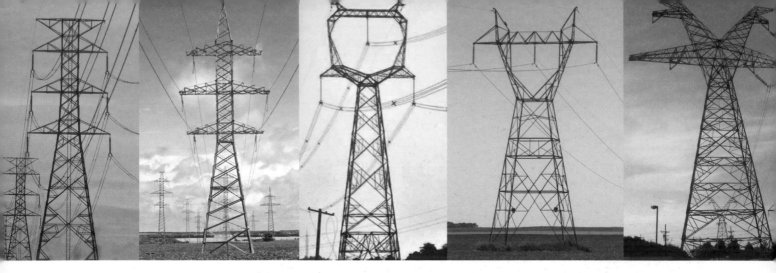

There is beauty in the everyday objects that surround us. Sometimes the most banal objects, on closer inspection, can become interesting and engaging.

Pylons

The standard electricity pylons that are now such a part of our landscape are an example of how we sometimes disregard the familiar. These great giants appear standing on the horizon with their outstretched 'arms' connecting across the landscape. There are enthusiasts and even appreciation societies for these towers. Love them or hate them, they are a great subject to draw.

Pylons are not uniform by any means. On close inspection, you will begin to notice the enormous variety of structures with different heights and widths (see above). The tops of the pylons feature a multitude of intertwining geometric shapes and forms.

1. Use a selection of materials, including pens and pencils – whatever you feel is appropriate. Draw a variety of different pylons. Look at their extraordinary patterns and shapes.

2. Get up close and scrutinise the details – for example, the porcelain insulator disks that connect the wires.

3. Stand back and draw the pylons within the context of the landscape. How do they relate to their natural environment?

4. Think about the hair-like wires that connect the pylons as a contrast to the heavy, thicker lines of the pylons themselves.

5. Look at how the lines of the metal framework help you to see, and draw, the perspective of the structure. Notice how the cables disappear off into the horizon. This could almost be seen as one-point perspective as shown on page 75.

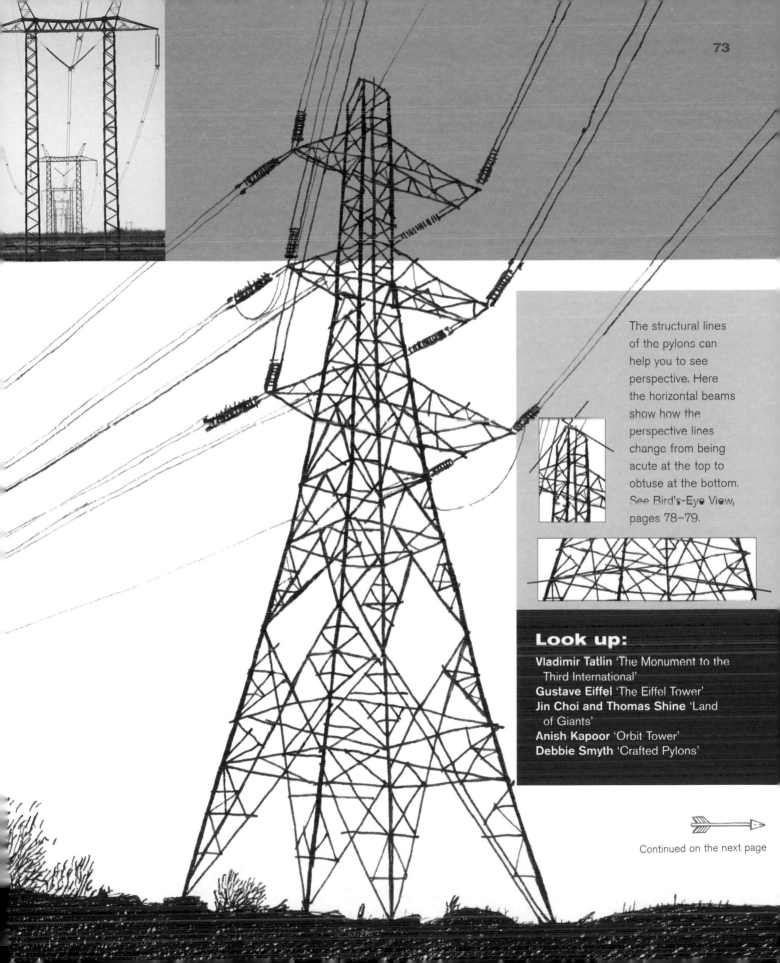

The structural lines of the pylons can help you to see perspective. Here the horizontal beams show how the perspective lines change from being acute at the top to obtuse at the bottom. See Bird's-Eye View, pages 78–79.

Look up:

Vladimir Tatlin 'The Monument to the Third International'
Gustave Eiffel 'The Eiffel Tower'
Jin Choi and Thomas Shine 'Land of Giants'
Anish Kapoor 'Orbit Tower'
Debbie Smyth 'Crafted Pylons'

Continued on the next page

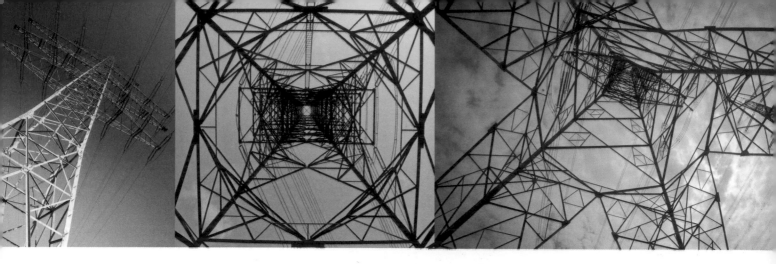

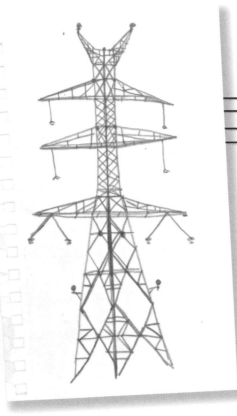

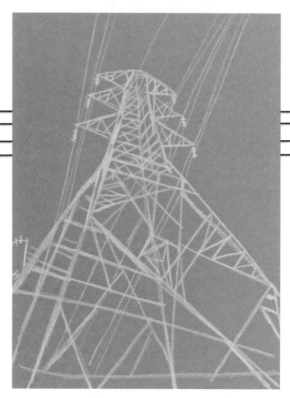

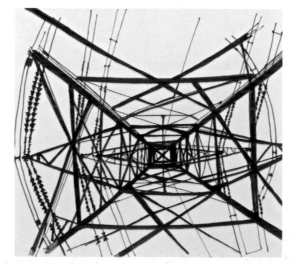

Looking at the above pylon face-on, we can see how symmetrical it appears. The geometric patterns it forms are reminiscent of a Christmas tree with baubles.

6. Draw them from different angles and look at the way that their structure transforms as your viewpoint changes. Look at how the tubular metallic limbs cross and intertwine.

7. Try drawing at an angle, looking up through the pylon. The structural lines will converge and forge together at different angles. Try a variety of approaches and mediums. Here, for example, the chalk lines give a sense of fragility and the shapes formed on the grey background can be seen in terms of negative space.

8. Look straight up through the centre of the pylon if possible (don't try this if the pylon is fenced off). Draw the repetitive structural grid, weaving a latticework web.

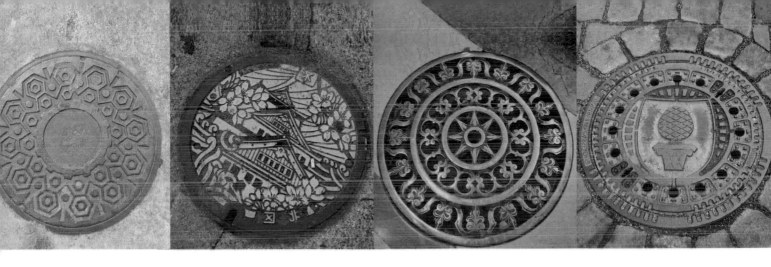

Drainspotting

Electricity pylons are not the only examples of fascinating shapes and patterns in the urban landscape; there are many others that often go completely unnoticed. Manhole covers are cast from iron, and feature designs varying from simple geometric patterns to decorative designs commemorating people, places or events. In Japan, almost all the municipalities have their own manhole cover designs celebrating their cultural identity. Explore your local area and see what artistic gems are literally lining the streets. Once you have drawn a few you'll want to keep adding to your 'drainspotting' collection. This exercise is a great way to explore how perspective affects circular shapes and patterns.

1. Look down at the ground and walk around until you spot an interesting design.

2. Take a photo as reference, make a quick sketch or take a large sheet of paper with you to make a rubbing.

3. Draw your manhole covers from over head as circles, and then as ellipses from different angles and viewpoints, examining how the shape of the cover and the details of the design conform to the rules of perspective.

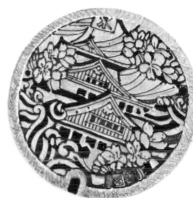

Vanishing point on horizon in one-point perspective.

VP

C Add decorative details, which are also in perspective.

B Draw an ellipse that fills the rectangle, touching all four sides, following the lines of perspective, to form your manhole cover.

A Draw a rectangle in perspective using one point lines as a guide.

Here you can see how a circular form will appear elliptical when it is viewed from an angle. Practise drawing these using the one-point perspective.

Look up:

Remo Camerota *Drainspotting: Japanese Manhole Covers*
Manhole cover art http://weburbanist.com/2011/12/06/manhole-cover-art-that-is-far-from-pedestrian/

Storm drains are also a great place to look for exciting street art.

When is a manhole not a manhole? When it's a cookie.

Get to grips with linear perspective from two points – and a low view.

Worm's-Eye View

Linear perspective is a concept based on how an individual observes and interprets an object, landscape or building from his or her own unique viewpoint. The lines of perspective, which are parallel to each other, meet at a point in the distance that is called the 'vanishing point'. Generally, this falls into two categories: one-point or two-point perspective.

A horizontal line drawn through the vanishing point depicts the eye level at which the scene is viewed. If you have a low viewpoint, this is called a 'worm's-eye view'. It will help you to develop your observational skills and will enable you to create a three-dimensional drawing on a flat surface.

During the early Renaissance, the artist Andrea Mantegna used 'worm's-eye view' perspective techniques to paint a series of frescoes inside the Ovetari Chapel of Sant'Agostino degli Eremitani. Sadly, the frescoes were destroyed during World War II. One of the frescoes, 'St. James Led to His Execution', represented this theatrical event viewed from below. Soldiers, towers and arches soared above the onlooker. The low viewpoint of the painting enhanced the emotion and drama of the scene.

See also:
Bird's-Eye View,
pages 78–79.

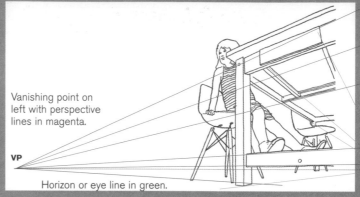

Vanishing point on left with perspective lines in magenta.

Vanishing point on right with perspective lines in blue.

VP

VP

Horizon or eye line in green.

1. You will need to lie down on the floor to see the world from an upwards perspective.

2. Take three different subjects and consider them from the viewpoint of a worm. It could be a building, block of flats or tree. It could be a person, looking up their nostrils or up their trouser leg!

3. Try to find your vanishing points by looking at where the lines of perspective converge. Sometimes they might be outside the area of your drawing. Holding a pencil at arm's length and matching the angles will help you find the points.

4. Draw a horizontal line through the vanishing point. This is your own personal viewpoint.

5. Pay careful attention to the distortions that you see and foreshorten where necessary.

The sizes and shapes that you know to be correct in the three-dimensional world will often appear incorrect in a two-dimensional drawing. Be true to the distortions you see before you. This point of view will give your drawing a more dramatic and striking quality.

Vanishing point

Look up:

Andrea Mantegna Frescoes of the Ovetari
Chapel in the Church of Sant'Agostino degli
Eremitani in Padua
Andrew Wyeth 'Christina's World'

You can find the two vanishing
points by plotting the angles with
a pencil consistently held at arm's
length. This method can also be used
to 'see' the lines of perspective for
each of the items.

Even small details obey the
same principle:
1 Thickness of wood on table frame.
2 The position of chair legs on
the ground.
3 The cross slats.
4 The chair back.

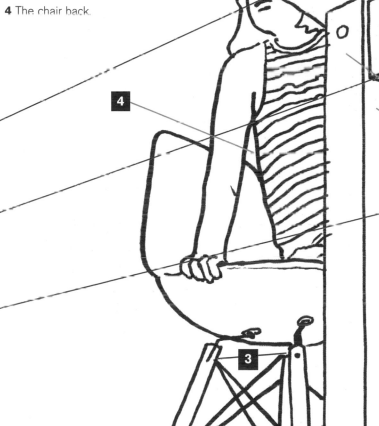
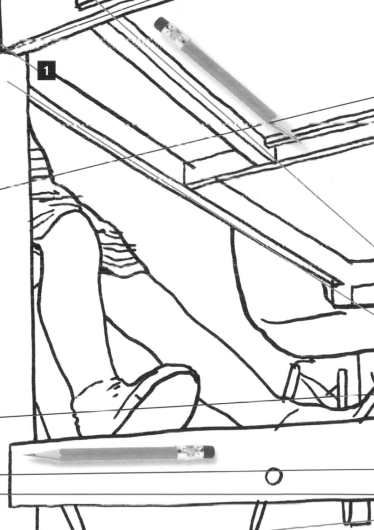

Bird's-Eye View

Think of yourself soaring above the ground, as if you were a bird in flight. You will see the world from a new perspective. This high viewpoint is called a 'bird's-eye view'.

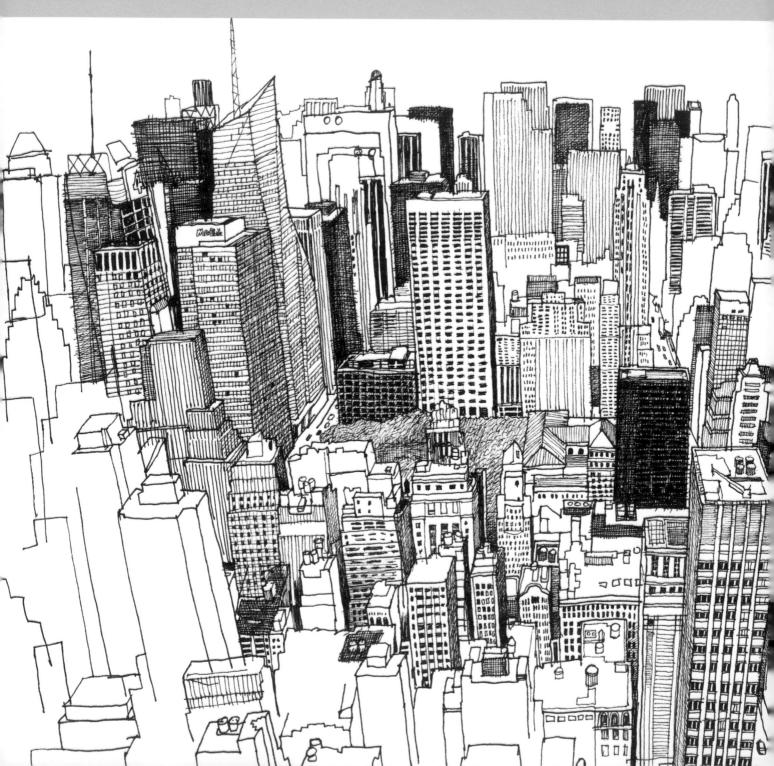

The first 'bird's-eye view' drawings were maps. They were imaginary constructs, drawn largely for functional reasons, to help us understand what we couldn't see with our own eyes. With the invention of flight, artists such as Kazimir Malevich and Georgia O'Keeffe became heavily influenced by aerial photography. Malevich's abstract paintings could be seen as flat representations, looking down at the world from above. When we look at an object or a scene from a completely different perspective, we see everything in a new light.

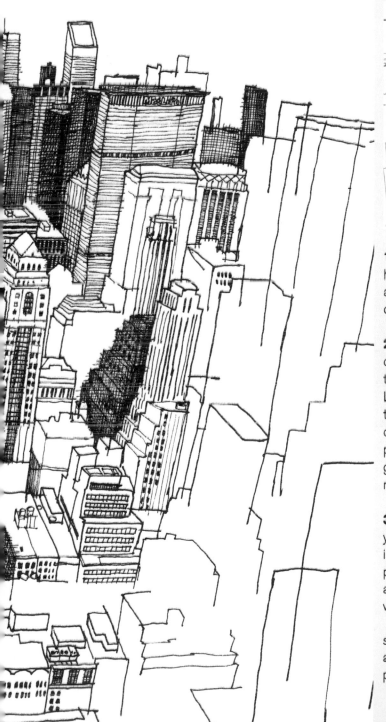

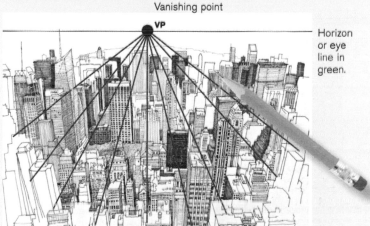

Vanishing point

Horizon or eye line in green.

1. You will need to find a high vantage point and look at your subject from a downwards perspective.

2. Climb a mountain, a hill or a tree. Look out from the top floor of a tall building. Look down from the gods at the theatre or from the top of a multistory car park. A pair of high heels just isn't good enough – you really need to be quite high up.

3. What do you see before you? One-point perspective is the simplest form of perspective, a depiction of an object or scene from one vanishing point.
 Looking down on your scene, find the horizon line and then mark a vanishing point at the centre of this line. This is the point at which the lines of perspective converge.

4. Now draw what you see before you, using these perspective lines as a guide.

See also: Worm's-Eye View, pages 76–77.

There are many ways of seeing and drawing. Technical drawing is not as frightening as you might first think – it is merely a way of representing three-dimensional space on a flat picture plane.

AXO–ISO

1. First, find a cuboid form. This might be a table, a chair, some packaging or even a very chunky book.

2. Place the object directly in front of you.

3. Make a quick sketch of the object so you can begin to understand its shape and dimensions.

4. Now, draw a horizontal line at the bottom of your paper. Use a protractor to project two 45-degree angles out at either side from a central point on the horizontal line. This is going to be an axonometric projection.

5. Begin to plot your cuboid form using these lines as a guide. The drawing doesn't have to be extremely precise; this is purely a starting point to help you understand how to approach technical drawing.

6. Draw another horizontal line at the bottom of your page, but this time project two 30-degree angles out either side of a central point. This will be an isometric projection.

7. Begin to plot your cuboid form using these lines as a guide.

First draw the chair as you see it in front of you. Keep it informal. There is no need to use a ruler and protractor at this stage.

In this exercise, you are going to look at axonometric and isometric drawings. Axonometric means 'to measure along axes'; isometric means 'equal measures'. The perspective lines in isometric and axonometric drawings never converge (unlike in a perspective drawing). Isometric drawings include lines at 30 degrees from the vertical (as well as vertical lines), while axonometric drawings have lines at 45 degrees. These projections may appear to be visually inaccurate and unrealistic but they are very helpful when interpreting buildings and interiors, for example, as they allow for precise measurements to be recorded and taken from the drawing. Modernists of the Bauhaus School fully embraced axonometry, as it was the perfect visual expression of their mantra, 'form follows function'.

Now you are going to try your hand at a simple form of technical drawing. You are going to look closely at a cuboid object and reproduce it twice, using the principles of axonometric and isometric projection. This will help you to understand two different ways to simulate a sense of depth and space.

AXONOMETRIC

The chair is rotated at 45° on the horizontal line, which is called the plane of projection, to create a view from above.

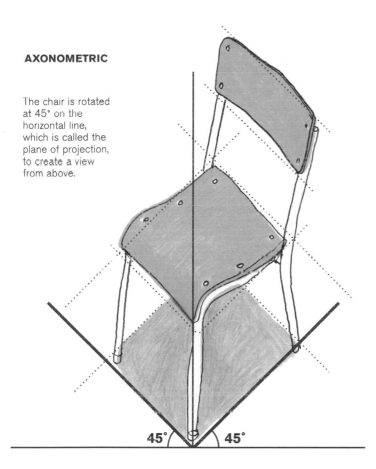

45° 45°

ISOMETRIC

Change the two angular lines to 30° from the plane of projection to draw the isometric projection.

30° 30°

Look up:

eBoy Pixel art eCity posters including 'Rio eCity' (left), 'Tokyo eCity' and 'New York eCity'

Chris Ware 'Jimmy Corrigan, the Smartest Kid on Earth'

M.C. Escher 'Waterfall'

Walter Gropius Architectural drawings of Törten housing estate

Theo van Doesburg Architectural drawings of Hotel Particulier

Inverse perspective, also called reverse perspective, is a way of rendering a drawing where the lines of perspective separate on the horizon, rather than meeting together as in linear perspective. The vanishing points are positioned outside of the drawing itself, giving the impression that they are coming out in front of the drawing towards the viewer.

Broaden Your Horizon

Inverse perspective allows the artist to reveal a series of viewpoints simultaneously. It combines the two separate perspectives at the same time, to create a unified image. East Asian artists, the Cubists and the Russian and Byzantine icon painters are among the many artists who have adopted this technique. Giotto di Bondone, the Byzantine master, completely amazed his audience with his unconventional use of perspective. His icon paintings used inverse perspective for the first time to create a sense of reality. The religious audience of his day had never before witnessed biblical scenes depicted in this way. He had created the illusion of three dimensions on a two-dimensional plane, and they were in awe of his magical visions.

Look up:

Giotto di Bondone 'St. Francis Renouncing His Worldly Goods'
Duccio di Buoninsegna 'Temptation on the Temple'
Andrei Rublev 'The Annunciation'
Utagawa Hiroshige 'View of Kagurazaka and Ushigome Bridge to Edo Castle'
Pablo Picasso 'Still Life with Chair Caning'

1. Look around your local area for interesting buildings.

2. Find a building that you can stand a good distance away from, and draw it face-on.

3. Now walk around it and draw the same building from a completely different viewpoint.

4. Combine the two different approaches and adapt the perspective of each drawing to open up the panorama.

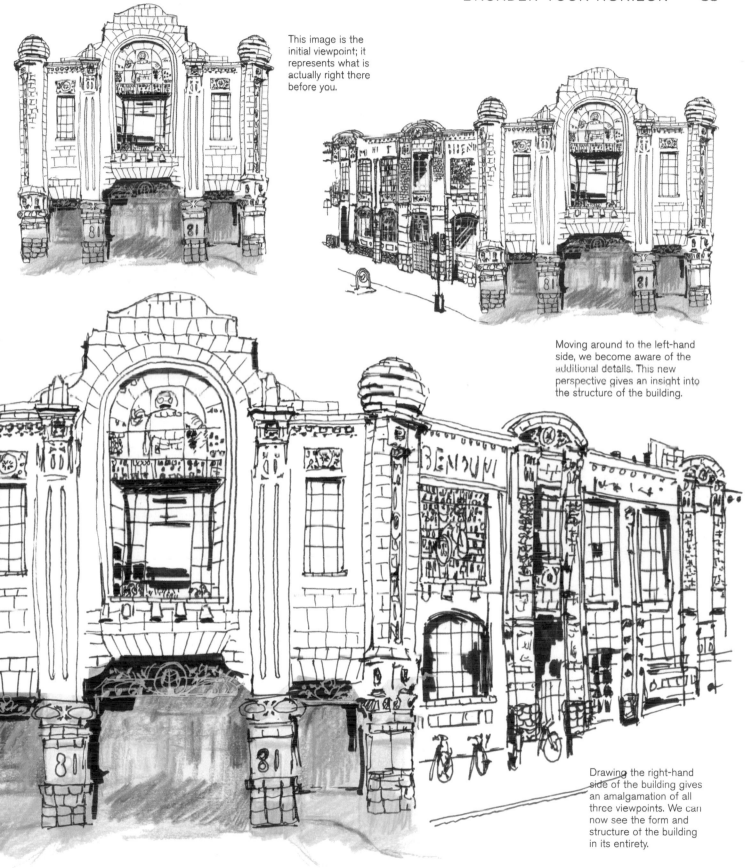

This image is the initial viewpoint; it represents what is actually right there before you.

Moving around to the left-hand side, we become aware of the additional details. This new perspective gives an insight into the structure of the building.

Drawing the right-hand side of the building gives an amalgamation of all three viewpoints. We can now see the form and structure of the building in its entirety.

CHAPTER

There are various methods that can be used to describe and emulate a sense of movement in your drawings. Here you will find ways to represent a sense of movement through spontaneous gestural marks and consider techniques to create the illusion of speed and motion. The aim of these exercises is to improve your observation and reaction skills.

Movement and Gesture

'People call me the painter of dancers, but I really wish to capture movement itself.'
Edgar Degas

Speed Draw

Create a sense of action and movement through quick gestural marks.

Choose a subject that is in motion, which you can draw quickly. You might seek out figures at a playground, a gymnasium, a swimming pool or a building site – any place where people are in motion. This is about intuitive mark making.

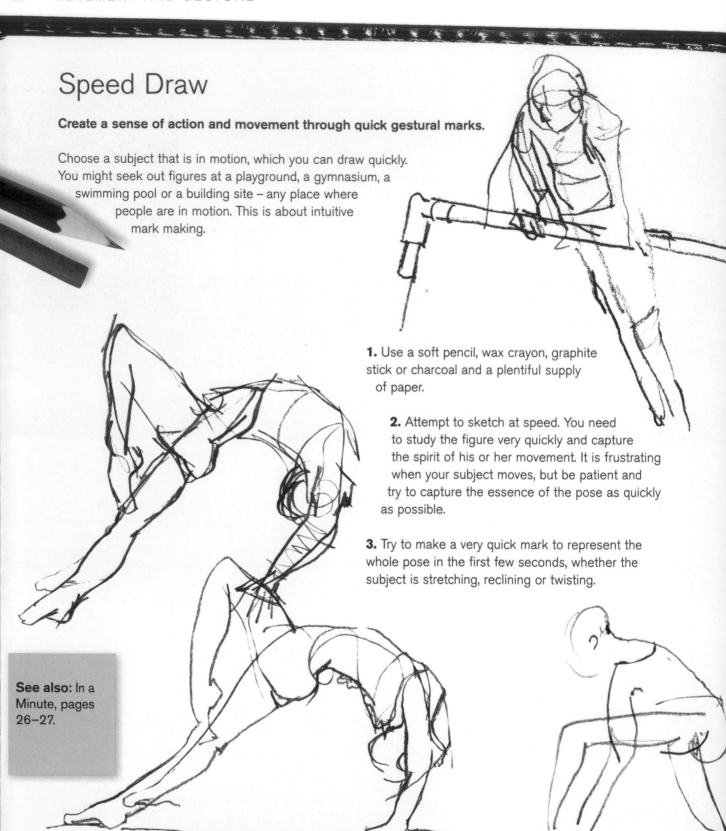

1. Use a soft pencil, wax crayon, graphite stick or charcoal and a plentiful supply of paper.

2. Attempt to sketch at speed. You need to study the figure very quickly and capture the spirit of his or her movement. It is frustrating when your subject moves, but be patient and try to capture the essence of the pose as quickly as possible.

3. Try to make a very quick mark to represent the whole pose in the first few seconds, whether the subject is stretching, reclining or twisting.

See also: In a Minute, pages 26–27.

4. Let your pencil dance on the page in one fluid movement. The pencil should follow the movement of the form, but you are not trying to represent the form itself. Determine what the figure is doing; only then will you be able to accurately interpret what you see.

5. Focus on the subject itself and try to be free with your drawing style. The images might look like a swirling mass of steel wool.

6. You should respond directly to the movement of the figure – feel the gesture in your body; it will help you to loosen up. Relax, bend and stretch in response to the figure. You should feel an affinity and a rapport with your subject.

7. Sum up the character of the pose with lines that swirl around the figure, to delineate the arms, legs, hips and knees. Is it elegant, aggressive, sluggish or relaxed? Everything has a quality and a gesture.

8. Draw from every viewpoint and draw all positions: leaning, stooping, sitting, standing. You'll be surprised at how quickly your observation and reaction skills improve with practice.

Look up:

Alberto Giacometti 'Femme Debout et Tête d'Homme'
Honoré Daumier 'Don Quixote and Sancho Panza' drawings
Rembrant van Rijn 'An Old Woman Holding a Child in Leading Strings'
Pablo Picasso and Gjon Mili Light drawings

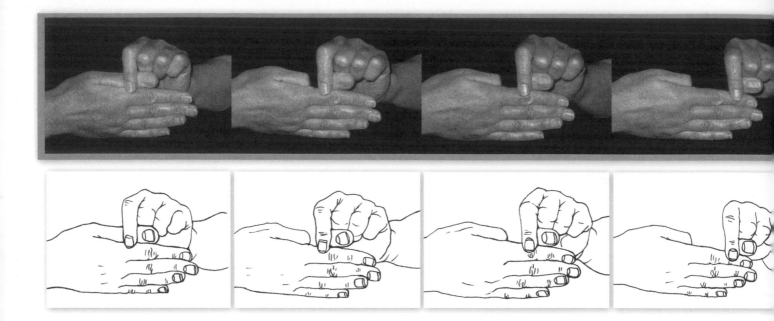

Time and Motion

Eadweard Muybridge was one of the most influential pioneers of photography in the nineteenth century. His groundbreaking motion–sequence still photographs were a precursor to cinematography.

In 1878, Muybridge produced a series of seminal photographs titled 'The Horse in Motion', in which he used a bank of large glass-plate cameras to photograph the sequential movement of a galloping horse. This study proved for the first time that a horse could have all four hooves off the ground at the same time. He later went on to invent the zoopraxiscope, which projected and animated his photographs to produce the illusion of movement.

Muybridge's photography has greatly influenced the work of many artists, including Edgar Degas, Francis Bacon and Marcel Duchamp. Duchamp's 1912 painting 'Nude Descending a Staircase, No. 2' was inspired by Muybridge's photographic study of a woman walking downstairs from 'The Human Figure in Motion' series of 1878.

Today, digital photography and image-manipulation software have radically changed the way we take and view photographs. We are now able to capture the world on our mobile phones, and these images can be easily adapted in creative and innovative ways. Inspired by Muybridge's work, you are going to produce a drawn version of sequential movements.

1. Your task is to make a flip book. Take a series of photographs of an object, animal or human in motion. You'll need at least 12 images to make the sequence flow.

2. Choose a movement that isn't too complicated – for example, someone walking or a bouncing ball.

3. Now that you have your photographic images, you can reproduce them as simple line drawings on separate sheets of thin card or paper.

4. Remember to directly overlay the images so that the sequence positioning is correct.

5. To finish your flip book, the paper must be fixed, glued or stapled at the top or along the side (depending on whether your images are horizontal or vertical).

6. Flip away and see your drawings come to life!

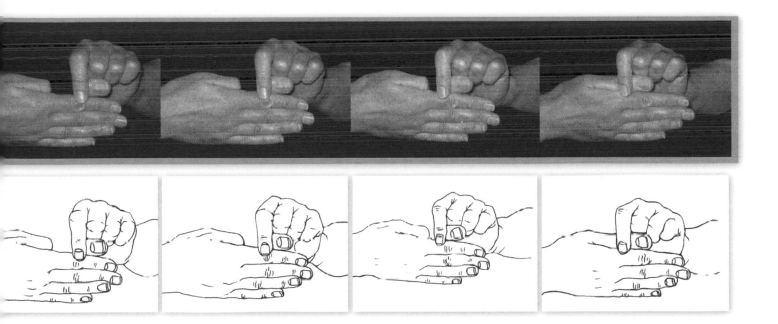

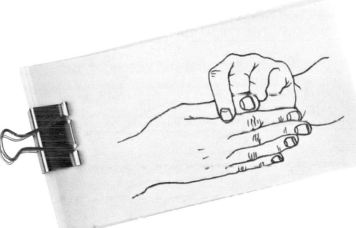

As you begin to flip the pages of the book, you will see the images merge together to create a lively animation. The hands move in sequence and the illusion of the dissected thumb moves backwards and forwards.

Look up:

Eadweard Muybridge 'Animal Locomotion' and 'The Horse in Motion'

Étienne Jules Marey 'La Machine Animale' and 'Le Mouvement'

Thomas Eakins 'Study in the Human Motion'

Marcel Duchamp 'Nude Descending a Staircase, No. 2'

Tim Macmillan 'Dead Horse'

Charles and Ray Eames 'Powers of Ten, a Flipbook'

The poet Filippo Marinetti published *The Futurist Manifesto* in 1909. He was the architect of the movement of the same name, which included artists such as Giacomo Balla, Luigi Russolo, Carlo Carrà, Gino Severini and Umberto Boccioni.

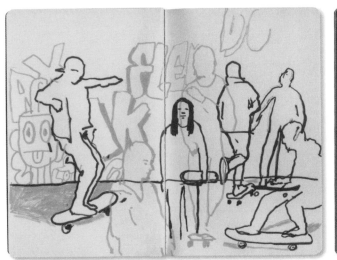 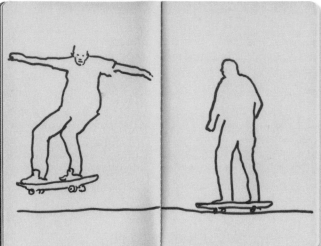

These sketchbook images show a variety of line drawings capturing the unique shapes and movements of the skateboarders.

Moving People

The Futurists were interested in the modern industrialised world and the expression of movement, speed and dynamism. Influenced by the sequential photographs of Étienne-Jules Marey and Eadweard Muybridge, they used various techniques to create a feeling of movement. They broke up lines and multiplied them, spacing them at intensifying intervals. They also painted with fragmented and shattered brushstrokes to give a sense of speed. These techniques were intended to represent the vigour and forcefulness of modern life. Their paintings, drawings and sculptures were dynamic depictions of the chaotic and accelerating world in which they found themselves.

Look up:

Luigi Russolo 'Dynamic Automobile'
Carlo Carrà 'The Red Horseman'
Gino Severini 'The North-South'
Umberto Boccioni 'Dynamism of a Cyclist'
Marcel Duchamp 'Nude Descending a Staircase, No. 2'

1. Position yourself in a place from where you can observe people on the move – an airport, a railroad or bus station, a busy shopping centre or a park, for instance.

2. Unfortunately, people on the move don't tend to stick around long enough for us to draw them. It can be very frustrating, and you will have to work incredibly fast to keep up with them.

3. Try to capture a sense of movement and action through the use of swift gestural marks.

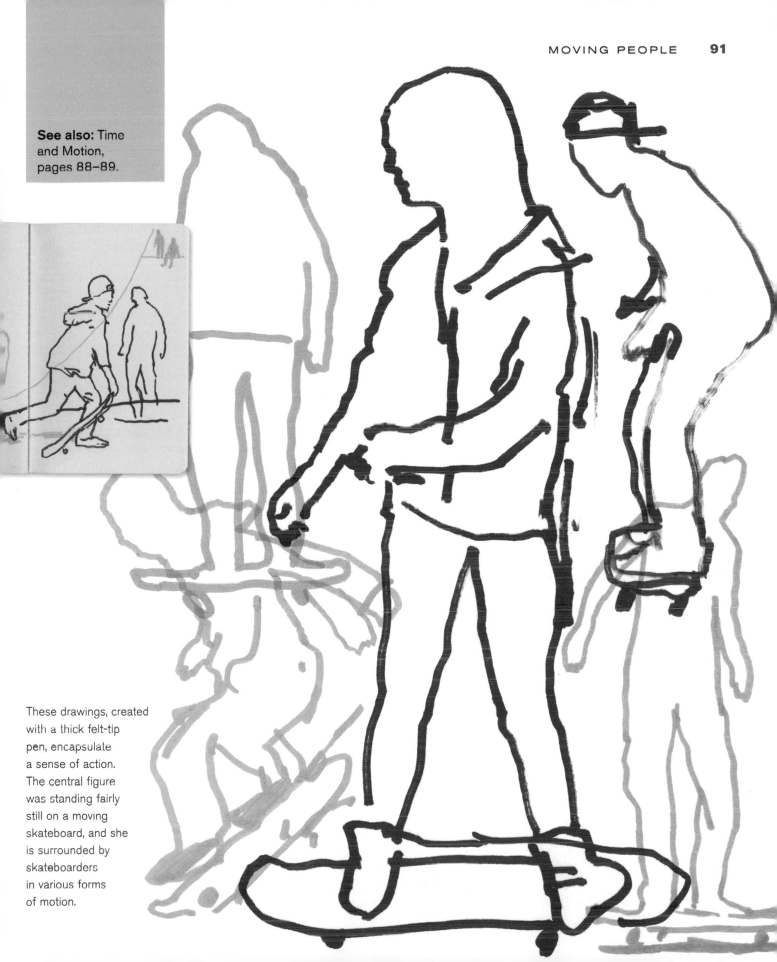

See also: Time and Motion, pages 88–89.

These drawings, created with a thick felt-tip pen, encapsulate a sense of action. The central figure was standing fairly still on a moving skateboard, and she is surrounded by skateboarders in various forms of motion.

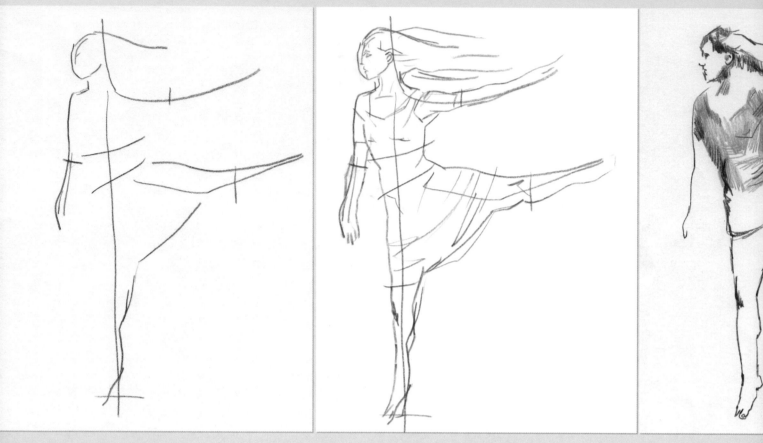

Frozen in Time

Many artists have been inspired by the excitement and energy of dance. Pablo Picasso, Henri Matisse and Jean Cocteau all collaborated with Sergei Diaghilev to create costumes and designs for the Ballets Russes, and Toulouse-Lautrec captured Jane Avril's cancan at the Moulin Rouge.

To Edgar Degas, the ballet expressed the movement and pulse of modern life. The ballerinas themselves were complex and inspirational models. They were perfect subjects for the study of the form in motion. Photographic developments had made it possible to capture a frozen moment in time, and artists such as Degas were inspired by what these images revealed. He could scrutinise a pirouette, *fouetté en tournant* or even a simple *plié* at length. He could capture a realistic feeling for movement using informed references. Marie van Goethem, 'Little Dancer of Fourteen Years', was a ballet student, and Degas made many drawings of her in a relaxed pose with her hands gently touching behind her back. He also made a sculpture of her, and its realistic stance amazed the audience of the day.

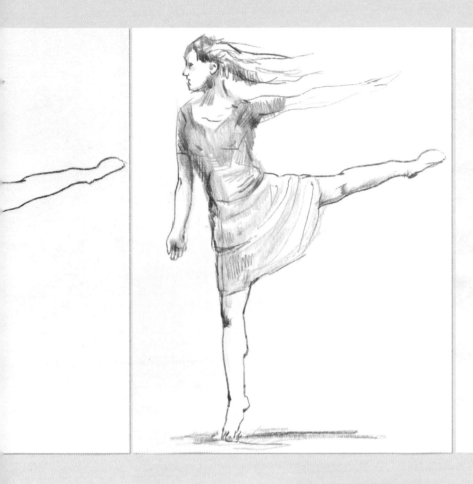

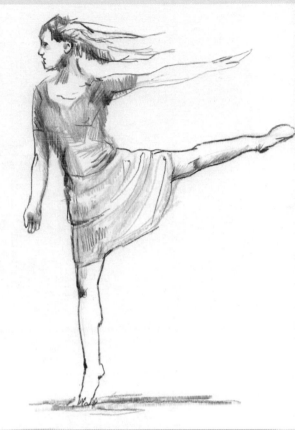

1. Attempt to understand the language of dance by capturing a frozen moment.

2. Find a place where people are dancing. This could be any form of dance: ballroom, ice dance, jazz, ballet, salsa, breakdance, tap or flamenco.

3. This exercise is really about you closely observing the dancer and his or her movements, and capturing a frozen moment in your mind. Try to avoid the temptation of taking a photograph to use as a reference.

4. Remember to observe the dancer's clothes, as the swirling and swishing of the fabric can enhance the sense of movement in your drawing.

Look up:

Edgar Degas Ballet dancer drawings including 'Dance Class at the Opera', 'Ballet Rehearsal' and 'The Star, or Dancer on the Stage' (right)
Toulouse-Lautrec 'Jane Avril'
Gillian Wearing 'Dancing in Peckham'
Lumière brothers Loïe Fuller's 'The Serpentine Dance'
Oskar Schlemmer bauhausdances.org

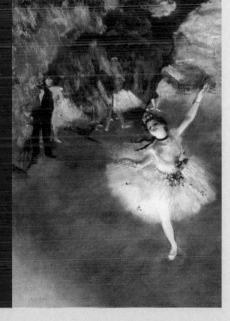

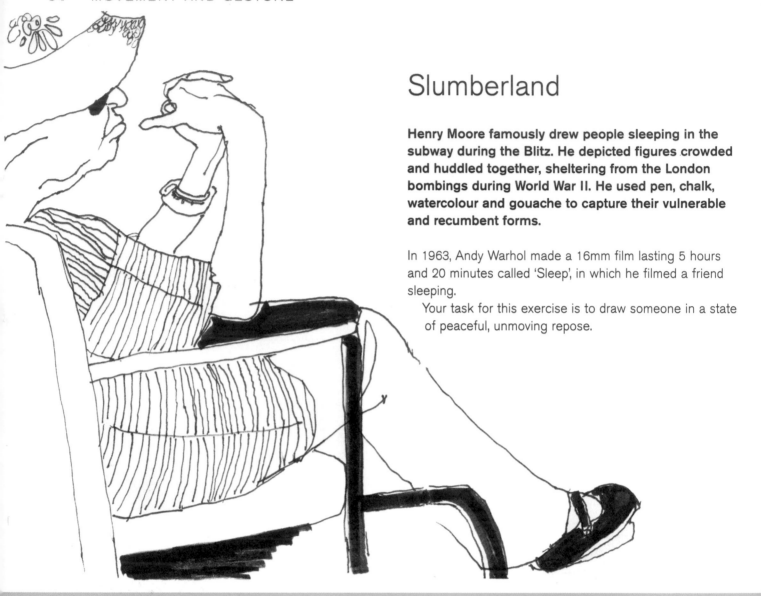

Slumberland

Henry Moore famously drew people sleeping in the subway during the Blitz. He depicted figures crowded and huddled together, sheltering from the London bombings during World War II. He used pen, chalk, watercolour and gouache to capture their vulnerable and recumbent forms.

In 1963, Andy Warhol made a 16mm film lasting 5 hours and 20 minutes called 'Sleep', in which he filmed a friend sleeping.

Your task for this exercise is to draw someone in a state of peaceful, unmoving repose.

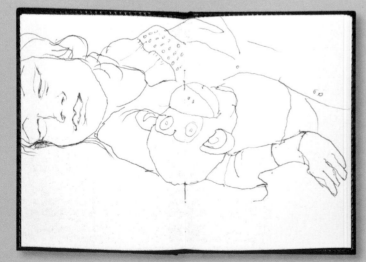

A face-on, close-up viewpoint of a sleeping child.

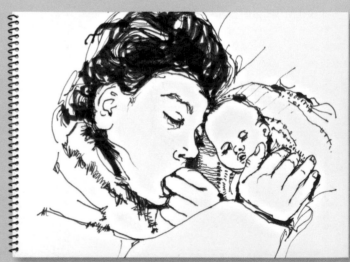

A study of a child with a doll, drawn from above.

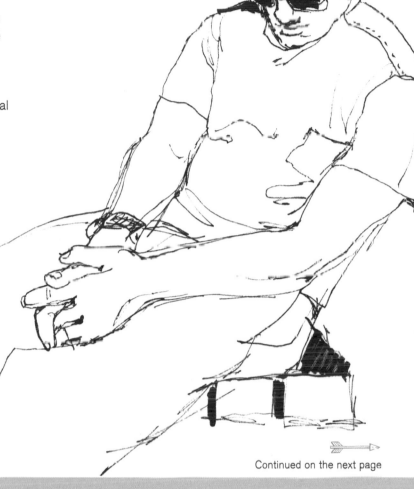

1. Find a sleeping figure – he or she could be on a train, in a park, on a beach or at home in front of the television. He or she is a captive subject.

2. Try to concentrate on capturing his or her form and character. He or she might appear beautiful, serene, comical or grotesque (with head thrown back and mouth agape).

3. The great thing about this exercise is that your subject will stay still as you draw. This is, of course, extremely useful when you are trying to draw children!

 Continued on the next page

A silhouette drawing of a girl asleep on a train.

Look up:

Andy Warhol 'Sleep'
Henry Moore 'Shelter Sketchbooks' and 'Lullaby Sketches'
Rembrandt van Rijn 'A Woman Sleeping'

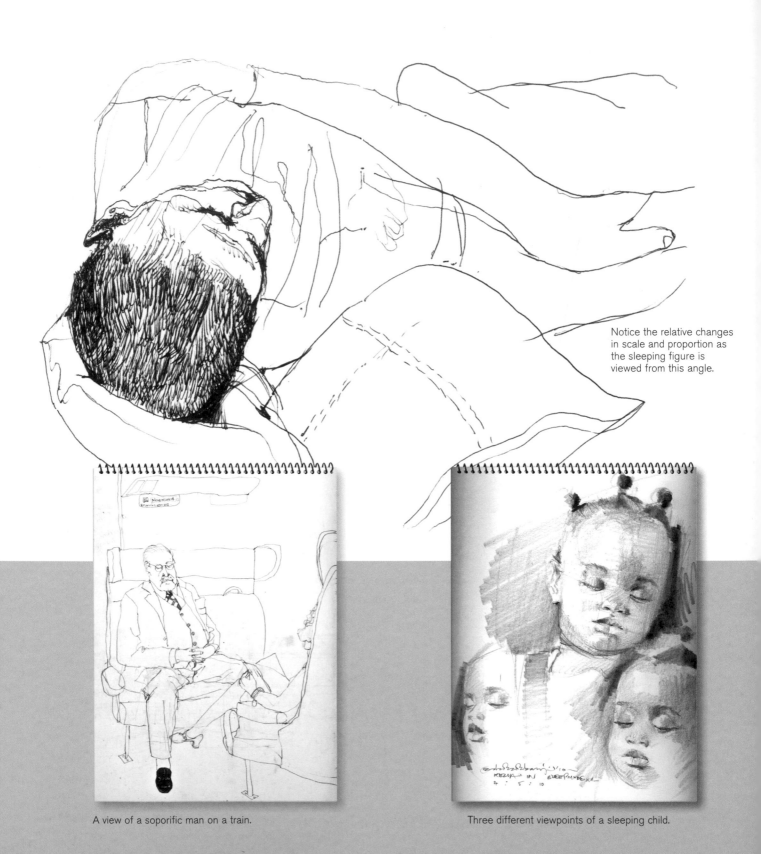

Notice the relative changes in scale and proportion as the sleeping figure is viewed from this angle.

A view of a soporific man on a train.

Three different viewpoints of a sleeping child.

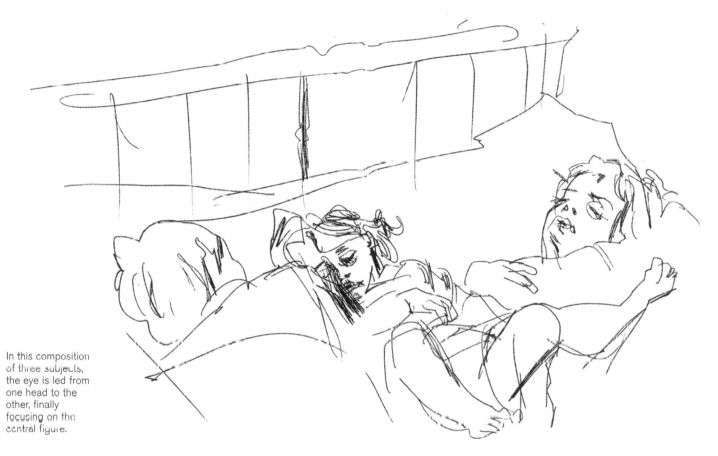

In this composition of three subjects, the eye is led from one head to the other, finally focusing on the central figure.

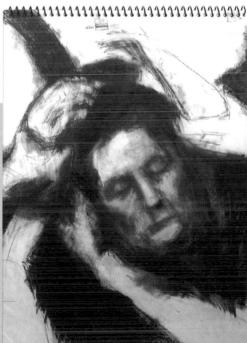

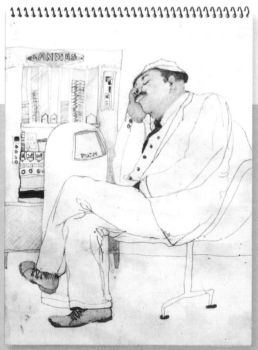

A dramatic *chiaroscuro* image captured from above.

A side view drawn slightly from below.

CHAPTER

In this chapter, you will create a variety of textures and patterns using different mediums and surfaces. Patterns that are repetitive or otherwise can give a very unique flavour to your drawings. The tasks will enable you to translate the illusion of texture onto the page through techniques such as rubbing, cross-hatching, shading and stippling.

Pattern and Texture

'No pattern should be without some sort of meaning.'
William Morris

To the Letter

Max Ernst invented a technique that he called 'frottage', directly inspired by the old wooden floor of an inn that he was staying at.

Ernst became intrigued by the floor's grain and texture, and began to make imaginative drawings by taking rubbings of its surface. He described this technique as a way of overcoming what he called a 'virginity complex'.

When stuck for ideas, making the first mark on a blank sheet of paper can often be quite a daunting prospect. Frottage is a great technique to help you loosen up and make you feel less reticent about making marks. The immediacy of this technique is incredibly satisfying, and these textures can also be used in tandem with more formal drawing. There is a plethora of possible textures that you can take rubbings from, but for this task you will be focusing on letter forms in your environment.

Look up:

Max Ernst 'Natural History' series
Kurt Schwitters and Theo van Doesburg
 'Dada Evening'
Eric Gill 'Alphabet and Numerals'

1 Go out onto the streets of your local area in search of letter forms that are either engraved or embossed – look on the pavement, walls, placards, street signs and gravestones, for instance.

2 Use lightweight drawing paper, newsprint or thin layout paper.

3 Place the paper over the letter form. With a soft pencil, graphite stick or pastel slowly work over the letter forms, taking rubbings of them. Study the textures. Look closely at where the type has been eroded over time and include any patterns that might surround the type.

4 Collect as many examples as possible and, when you feel you have collected a variety of textures, shapes and patterns, compose your letter forms on a larger sheet of paper. Make a collage of them to create a new composition of your own.

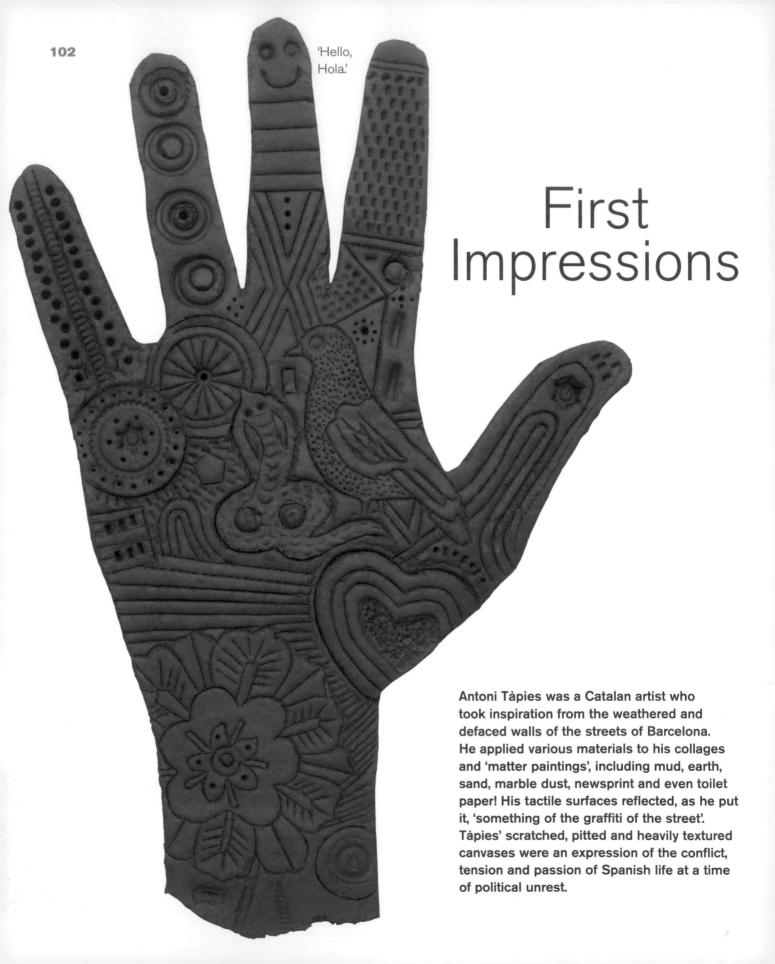

'Hello, Hola.'

First Impressions

Antoni Tàpies was a Catalan artist who took inspiration from the weathered and defaced walls of the streets of Barcelona. He applied various materials to his collages and 'matter paintings', including mud, earth, sand, marble dust, newsprint and even toilet paper! His tactile surfaces reflected, as he put it, 'something of the graffiti of the street'. Tàpies' scratched, pitted and heavily textured canvases were an expression of the conflict, tension and passion of Spanish life at a time of political unrest.

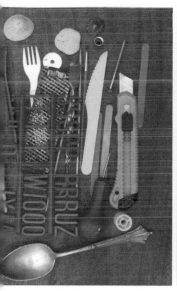

Drawing is a vehicle for self-expression. It can be a physical response to the world around us, and we can create marks in many ways. We don't have to restrict our mark making to pencil and paper only. You can practise producing textures and patterns by making your own 'matter paintings'.

Use your mark-making tools to scrape, stipple and stamp into the surface of clay. Use a combination of tools and techniques to make as many interesting marks and impressions as possible.

1. Find some scratching tools – a cocktail stick, the end of a watercolour paintbrush, an empty biro, a tapestry needle, a knitting needle, a compass point, a comb or an awl.

2. Find a thick piece of modelling clay. You can use air-drying clay, polymer clay or (if you are feeling more adventurous) you could attempt to make homemade modelling clay (see recipe). Roll out the clay on a board until it is about 5–10mm (¼–½in) thick. You are aiming for a flat area of around 30 x 15cm (12 x 6in)

3. Now begin to experiment with your tools. Use different types of strokes to create a variety of unusual textures. You can try hatching, cross-hatching or stippling. You could then bake the clay and create a print by applying ink or paint to it.

Modelling clay recipe
225g (8oz) salt
300g (10oz) flour
4 tablespoons cream of tartar
4 tablespoons vegetable oil
500ml (16fl oz) water

Stir all the ingredients together in a pot. Cook over a low heat, stirring continuously, until the clay thickens. Let the clay cool before using it. If you want to keep the clay, put it in an airtight container or wrap it tightly in a plastic bag. Store it in the fridge.

Look up:

Antoni Tàpies Matter paintings
Frank Aurebach 'Looking Towards Mornington Crescent Station – Night'
Grayson Perry 'Cuddly Toys Caught on Barbed Wire' and 'Barbaric Splendour'
Ben Long 'Boy and Dog Truck Drawing' and 'Owl Truck Drawing'
Lucio Fontana 'Spatial Concept' series

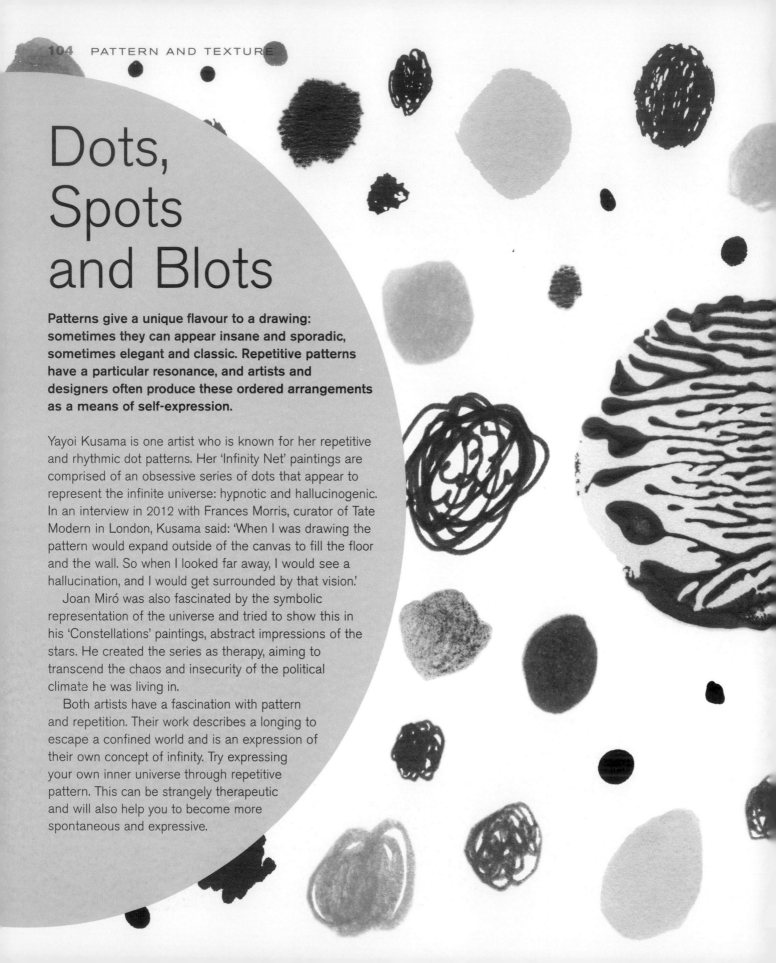

Dots, Spots and Blots

Patterns give a unique flavour to a drawing: sometimes they can appear insane and sporadic, sometimes elegant and classic. Repetitive patterns have a particular resonance, and artists and designers often produce these ordered arrangements as a means of self-expression.

Yayoi Kusama is one artist who is known for her repetitive and rhythmic dot patterns. Her 'Infinity Net' paintings are comprised of an obsessive series of dots that appear to represent the infinite universe: hypnotic and hallucinogenic. In an interview in 2012 with Frances Morris, curator of Tate Modern in London, Kusama said: 'When I was drawing the pattern would expand outside of the canvas to fill the floor and the wall. So when I looked far away, I would see a hallucination, and I would get surrounded by that vision.'

Joan Miró was also fascinated by the symbolic representation of the universe and tried to show this in his 'Constellations' paintings, abstract impressions of the stars. He created the series as therapy, aiming to transcend the chaos and insecurity of the political climate he was living in.

Both artists have a fascination with pattern and repetition. Their work describes a longing to escape a confined world and is an expression of their own concept of infinity. Try expressing your own inner universe through repetitive pattern. This can be strangely therapeutic and will also help you to become more spontaneous and expressive.

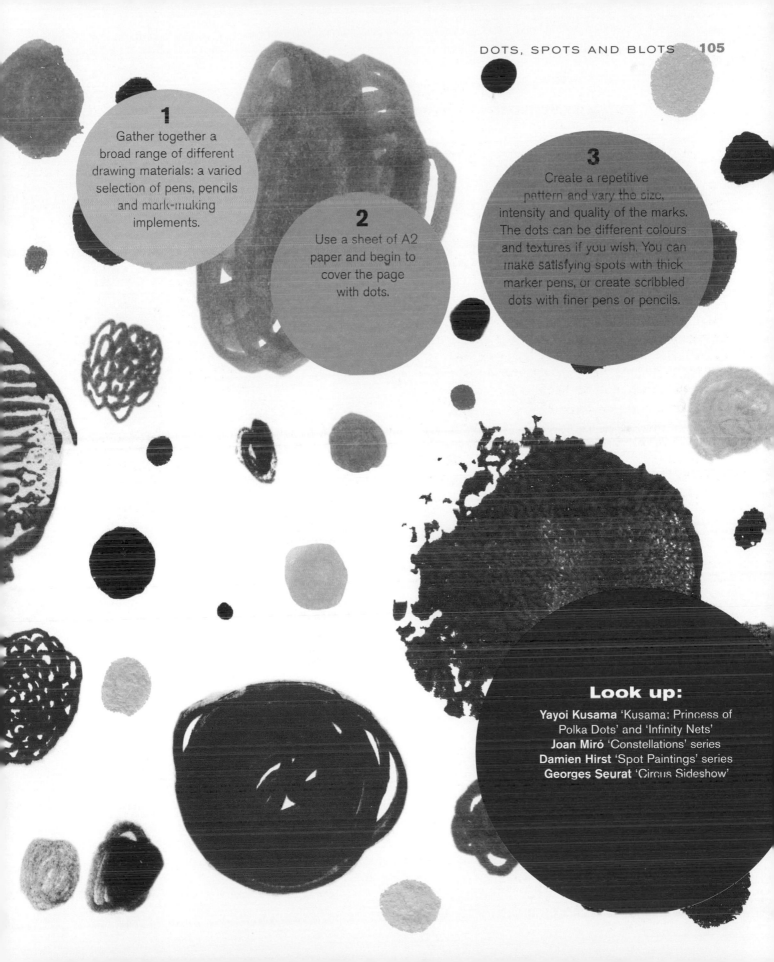

1

Gather together a broad range of different drawing materials: a varied selection of pens, pencils and mark-making implements.

2

Use a sheet of A2 paper and begin to cover the page with dots.

3

Create a repetitive pattern and vary the size, intensity and quality of the marks. The dots can be different colours and textures if you wish. You can make satisfying spots with thick marker pens, or create scribbled dots with finer pens or pencils.

Look up:

Yayoi Kusama 'Kusama: Princess of Polka Dots' and 'Infinity Nets'
Joan Miró 'Constellations' series
Damien Hirst 'Spot Paintings' series
Georges Seurat 'Circus Sideshow'

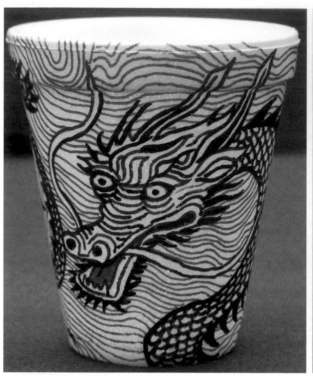 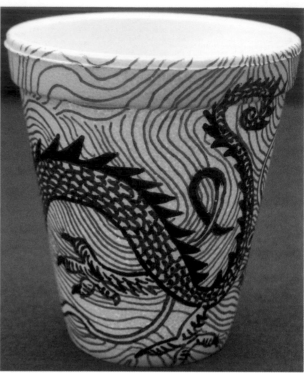

Remember that your cup can be seen from every angle. Your design will wrap around 360 degrees.

Coffee Cup Doodles

Pattern can be appropriated and applied to many surfaces, including fabrics, ceramics, shoes, furniture, tiles, wallpaper and even the skin in the form of tattoos. It's fun to draw onto surfaces other than paper and customise and enhance everyday objects.

The American artist Keith Haring wanted to make his work more accessible to the public and did this by applying his designs to various products, from T-shirts to toys. He opened his seminal Pop Shop in New York in 1986 to sell these products to his adoring fans, who could otherwise only dream of being able to afford one of his paintings. His work was steeped in the burgeoning graffiti and hip-hop culture of the 1980s.

Haring's unique visual style had a thick, hard-edged black line, often drawn with felt-tip pens and permanent markers. His designs were comprised of abstract shapes and symbols and included, among other things, motifs such as dogs, television sets and cartoon characters. His spontaneous, fluid lines and patterns tied his drawings together and became his distinctive personal signature.

We barely give a thought to the humble polystyrene or paper cups that we drink coffee from and they are duly discarded once they have served their purpose. For this exercise, you are required to keep hold of any spent cups from coffee and transform them into patterned works of art.

Look up:

Cheeming Boey Coffee cup gallery,
www.iamboey.com
Keith Haring www.haring.com
William Morris 'Pink and Rose'
Takashi Murakami 'Flower Ball'
Geoff McFetridge 'Monster Dice'

1. Collect polystyrene or paper cups. Polystyrene cups aren't biodegradable, so a paper cup is the more eco-friendly choice.

2. Using permanent markers (fine or medium), begin to create a pattern around the cup. If you prefer customising your cup immediately after drinking your coffee and you don't have a pen at hand, you can use a sharp fingernail to score the surface.

3. The design can be abstract or figurative – it's up to you – but remember that your design has to eventually wrap around the curved surface of the cup. The pattern should eventually connect with your starting point. It might be one motif (such as a snake or a dragon) or lots of smaller images that fill the area.

4. Don't be afraid to make mistakes; just let your imagination take control.

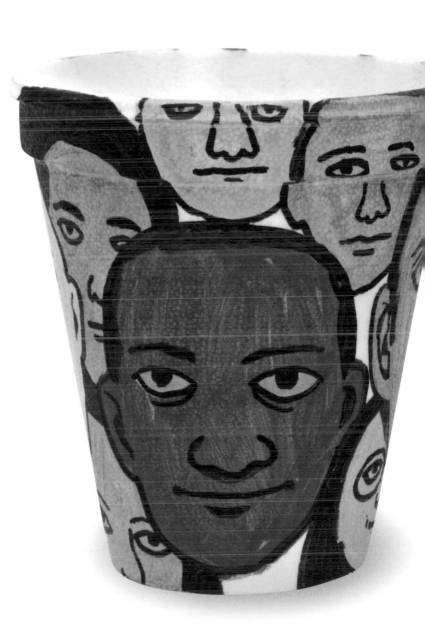

Hanging on the Telephone

Doodling is something that happens spontaneously and naturally. Doodles often seem to surface during a tedious meeting or when chatting on the telephone. They often expose unconscious thoughts, and can sometimes reveal a person's state of mind. However, many graphologists feel that a person's character cannot be assessed from their doodles alone.

Graphologists have codified many of the common images that are employed when doodling. For example, it won't come as a surprise to read that hearts are drawn to signify being in love, food doodles are particularly popular in boardrooms and classrooms close to lunchtime, and staircases can reveal a person's ambition and will to succeed. You can take inspiration from these unconscious

See also: Coffee Cup Doodles, pages 106–107.

and informal drawings. Let your doodles take centre stage – no longer need they be consigned to the margins of the page.

1. It is incredibly important to keep a pen and sketchbook close to the telephone. Keep the sketchbook open at all times, so that you can make immediate and spontaneous marks when receiving or making a call.

2. Doodling is the perfect antidote to those occasions when you are annoyingly kept on hold.

3. Feel free to express your frustrations on the page when muzak is inflicted on you.

4. Once the call is over, take an overview of the patterns and shapes that you have created.

5. Finally, turn the page in preparation for the next call.

Drawing is our unique visual response to the world, and this chapter will encourage you to look and think differently. You will explore and develop the connections among hand, eye and subject. The exercises that follow will help you to expand your creative decision making and also explore the vast potential of mixed-media drawing.

Observation, Exploration and Imagination

'You can make the drawing you want to make. You can make your drawing out of your fantasy. You can make a drawing of what's right there, but there's no correct way to do this.'
Richard Serra

Feet First

To respond to something well, in terms of drawing, it is sometimes important to understand the inner structure of your subject matter. This is especially true when we think about human anatomy.

Look up:

Andreas Vesalius 'De Humani Corpis Fabrica' believed to be illustrated by Titian's pupil Jan Stephen van Calcar
Leonardo da Vinci Anatomical studies

Developing a greater understanding of the human form can be aided by observing what happens under the skin – the human skeleton, muscles and ligaments. Leonardo da Vinci and Andreas Vesalius were able to make detailed studies of the human form by dissecting cadavers. Da Vinci dissected at least 19 corpses and made countless anatomical sketches.

Your task is to explore and draw perhaps the most unglamorous part of your anatomy – your feet. The foot has 26 bones, 33 joints, and more than 100 ligaments, muscles and tendons. Unlike da Vinci and Vesalius, you probably won't have access to a cadaver to dissect, so you can refer to their drawings to help you gain an insight into the inner workings of your own feet.

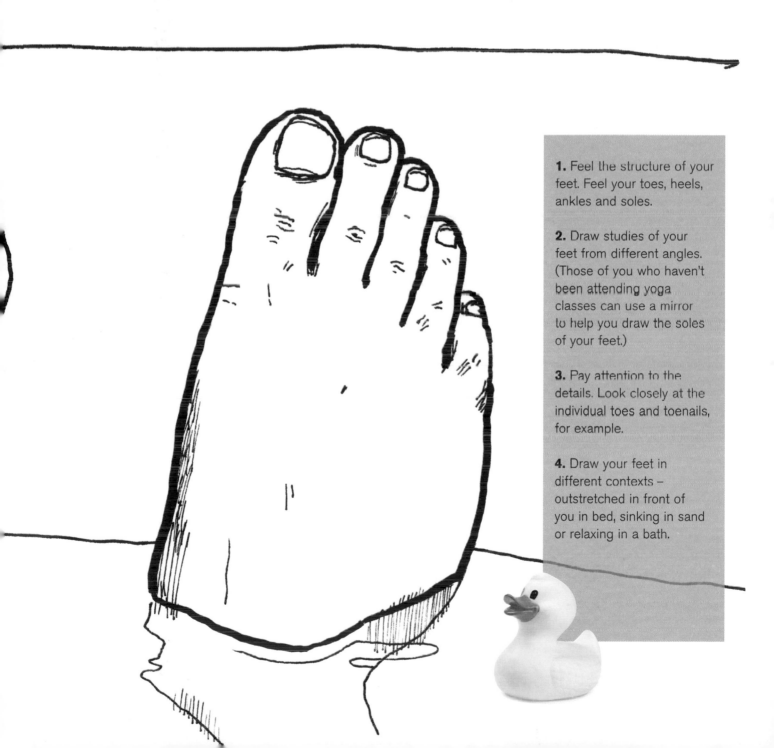

1. Feel the structure of your feet. Feel your toes, heels, ankles and soles.

2. Draw studies of your feet from different angles. (Those of you who haven't been attending yoga classes can use a mirror to help you draw the soles of your feet.)

3. Pay attention to the details. Look closely at the individual toes and toenails, for example.

4. Draw your feet in different contexts – outstretched in front of you in bed, sinking in sand or relaxing in a bath.

'"Contrariwise,"
continued Tweedledee,
"If it was so, it might be;
and if it were so, it
would be; but as it isn't,
it ain't. That's logic."'

Through the Looking-Glass
by Lewis Carroll

This exercise will help to develop your looking and thinking skills. You will have to really concentrate and carefully consider the marks you are making. You are going to use the 'looking glass' as a tool to help you analyse your drawings.

The task was inspired by Leonardo da Vinci, who made many notes in the form of 'mirror writing'. He was able to switch effortlessly to this informal manner of writing. He probably used his mirror writing as a secret code; however, we are unclear as to his motivation for writing in this way. You are now going to switch from your own reality into a backwards world through drawing.

Look up:

Réne Magritte 'La Reproduction Interdite'
Leonardo da Vinci Mirror writing

TIME TO REFLECT

1. Find a cereal box (or similar packaging with typography) and place it on a table close by.

2. First, draw a tonal representation of the box in front of you, making sure that you include the prominent typographic details.

3. Look at the angle of the box and remember to record where the light falls on the lid and the box itself.

4. Use shading and cross-hatching to darken the areas in shadow. This drawing will be used as a point of reference for the next stage.

5. Now set up a mirror in a stable position.

6. Sit with your sketch pad positioned so that you can see the reflection of your blank sheet in the mirror.

7. Set up your original drawing in front of you. Now keep your gaze fixed only on the mirror and start to reproduce your drawing of the cereal box. This is where the typography comes into play, as this is particularly challenging to reproduce.

8. It's a very tricky task – you will feel that your hand is pulling in the opposite direction. It's much easier to work at a snail's pace; you will find that your brain slowly adjusts to this challenge and can figure out the correct direction to take the pencil.

9. Finally, look away from the reflected drawing to the actual drawing you have made on the paper. You will probably have a rather scribbled reversed image

TIME TO REFLECT

Magnifly

An exercise to develop your observational skills.

Take inspiration from looking at scientific and botanical illustrations. You will discover the hidden textures, patterns and details of life. Analyse the form of something that you wouldn't normally study. Robert Hooke was a scientific genius who published a book of his own illustrations of insects and cells. He viewed his subjects through a powerful microscope that he himself had designed. *Micrographia* was published in 1665 and subtitled, *Minute Bodies, Made By Magnifying Glasses*. The book included large copperplate engravings and fold-out spreads of the most intricate and detailed studies.

1. Swat an annoying fly!

2. Using a magnifying glass or microscope, spend a long time studying your specimen.

3. Take a large sheet of paper. Using a soft pencil, lightly draw in the outline shape so it fits the paper.

4. Take a fine pen or B pencil and start to make a detailed investigation on your sheet of paper.

5. Discover the details and pay attention to the form of the fly.

6. Use hatching, cross-hatching and random marks to build up tone.

BUILDING UP TONE

In the thorax, lay down a single layer of diagonal lines (called 'hatching'), generally following the direction of the hairs.

Build up another layer of diagonal hatching in different directions to make cross-hatched marks, leaving some areas as highlights to give form.

Repeat more layers of hatching to build up tone, then define the details with a stronger drawn line.

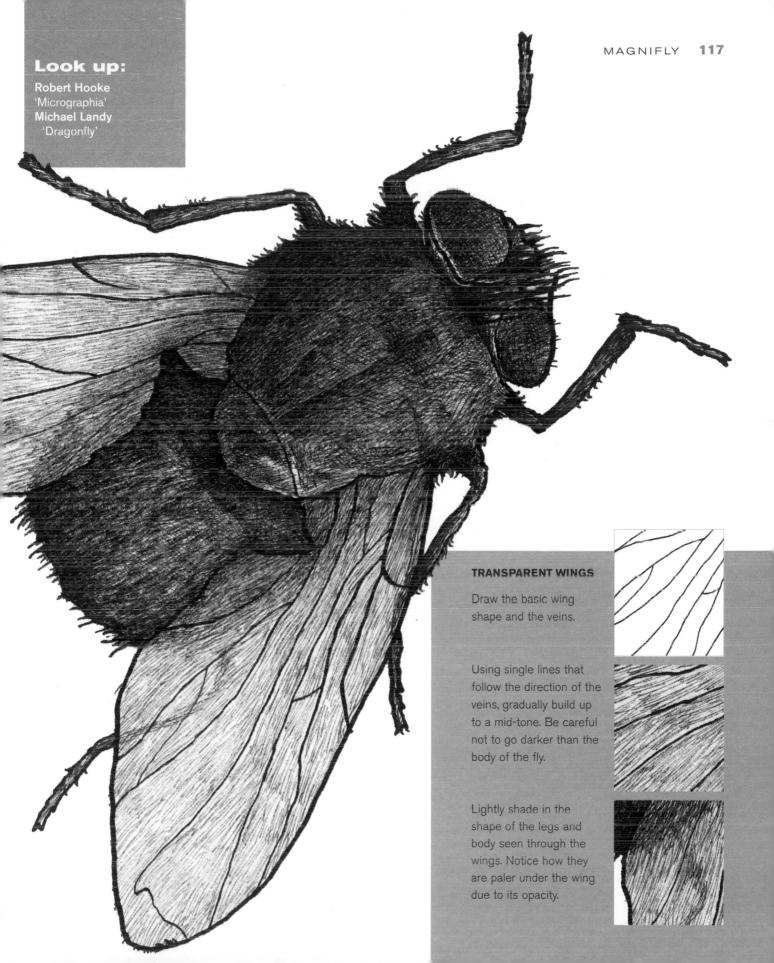

Look up:
Robert Hooke
'Micrographia'
Michael Landy
'Dragonfly'

TRANSPARENT WINGS

Draw the basic wing shape and the veins.

Using single lines that follow the direction of the veins, gradually build up to a mid-tone. Be careful not to go darker than the body of the fly.

Lightly shade in the shape of the legs and body seen through the wings. Notice how they are paler under the wing due to its opacity.

Decompose

Many artists have been fascinated by the mutability of life and have tried to find ways to describe the ephemeral and transient passage of time.

Dieter Roth was an artist known for using decaying food to create his paintings and sculptures; he was sometimes known as 'Dieter Rot'. There is a long history of *nature morte* (dead nature) in art – using rotten food as a symbol to represent the fragile cycle of life. This exercise is a marriage of still life and sequential drawing.

1. Root around in the kitchen for an item of food that has a short shelf life.

2. Place a bell jar or glass bowl over it and watch it decompose. Make a drawing every day over the course of a week (or until you can't stand the smell anymore).

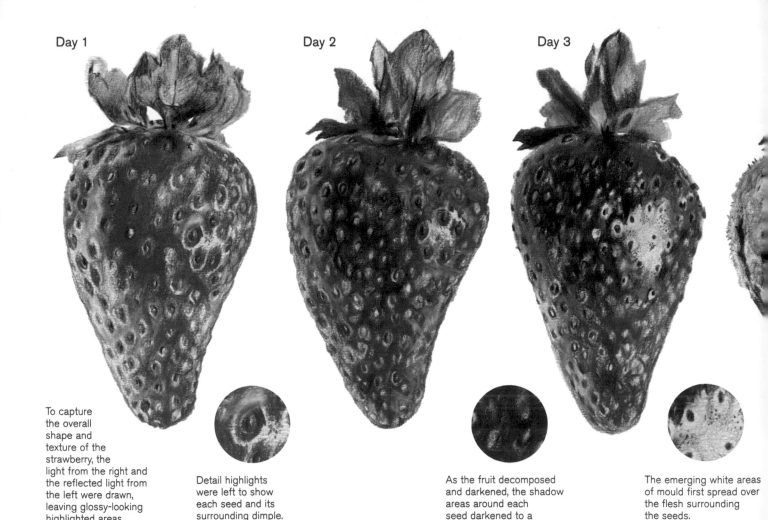

Day 1

Day 2

Day 3

To capture the overall shape and texture of the strawberry, the light from the right and the reflected light from the left were drawn, leaving glossy-looking highlighted areas.

Detail highlights were left to show each seed and its surrounding dimple.

As the fruit decomposed and darkened, the shadow areas around each seed darkened to a blue-purple colour.

The emerging white areas of mould first spread over the flesh surrounding the seeds.

3. Use coloured pencils or crayons for the drawings, as the food will probably dramatically change colour as it begins to rot. Draw the results stage by stage, as it you were making a storyboard. What changes does the food go through? Look at how it gradually putrefies and carefully record these changes. Does the food spoil and wither? Does it reshape and transform as the bacteria begins to take hold and break down its structure? Is there an insect infestation? This series of drawings will be a disintegrating and festering narrative.

Look up:

Damien Hirst 'The Physical Impossibility of Death in the Mind of Someone Living'
Carlo Laszlo Portrait made with processed cheese
Dieter Roth 'Staple Cheese (A Race)'
Klaus Pichler 'One Third'

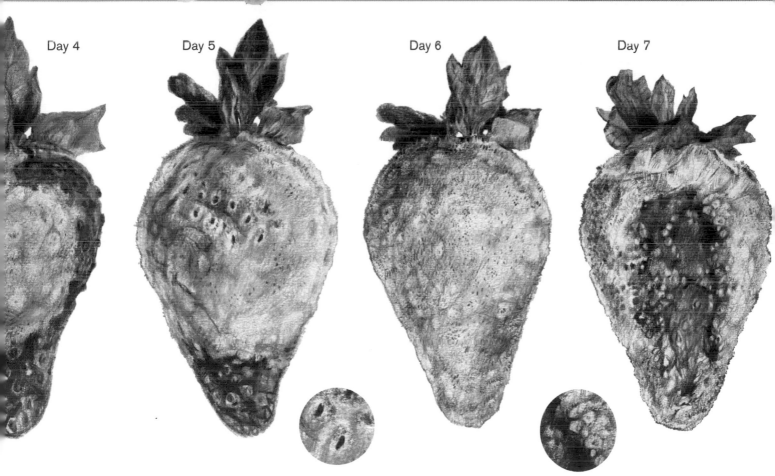

Day 4

Day 5

Day 6

Day 7

The appearance of the white, powdery mould was created by using a combination of soft graphite pencil and toned coloured pencils, once again leaving areas clear to create highlights. The overall shape of the strawberry can still be seen, as there is a stronger shadow tone to the left.

Some of the pips still remain with their little surrounding highlights to imply they are pitted in the surface.

The mould continues to develop, and eventually disintegrates into a dark and pulpy goo.

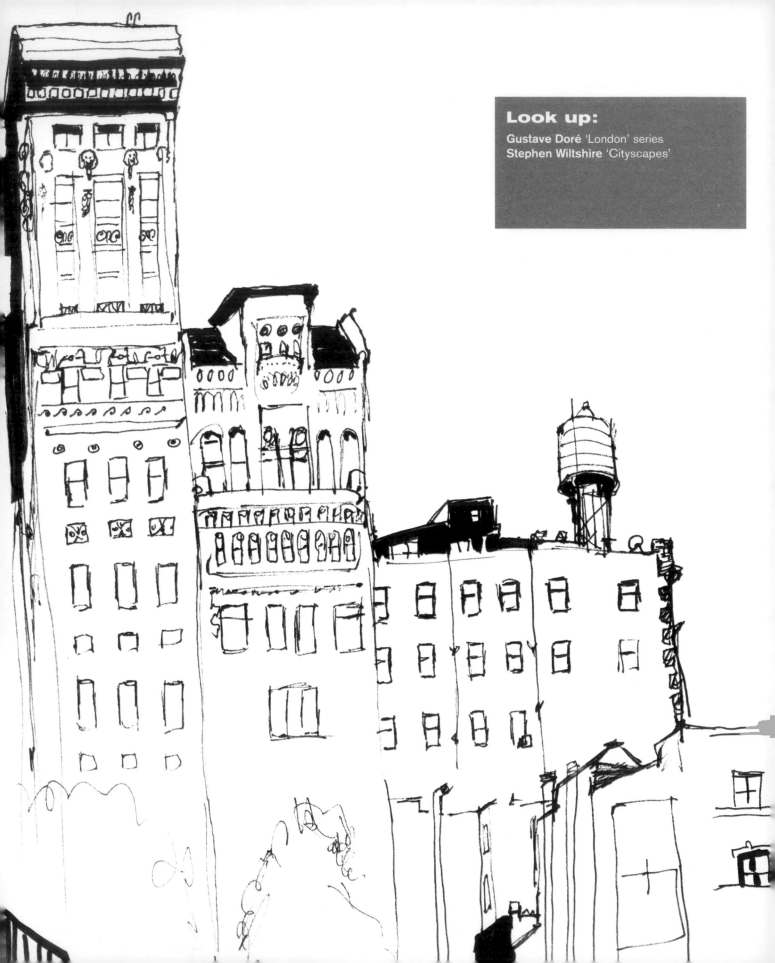

Look up:

Gustave Doré 'London' series
Stephen Wiltshire 'Cityscapes'

This is a test to enhance your powers of recall. It will help you to observe and understand your subject fully. Many artists have prodigious visual memories.

If Your Memory Serves You Well

Gustave Doré drew on his astonishing ability to remember scenes and characters when he was making a series of etchings depicting the streets of late nineteenth-century London. He would return from his observational excursions with a few very rough sketches but was able to re-create the scenes in incredible detail. His colleague Blanchard Jerrold recalled how 'he carried everything that he needed in his head'.

Edgar Degas also believed that drawing from memory was extremely important, as it helped to heighten the imagination.

You can improve your drawing skills by developing your memory skills.

1. Sit in front of an interesting or unusual building for 10 minutes and make a mental note of it, studying its basic structure and all its details. The more you concentrate on your subject, the more accurately you will be able to record it.

2. Walk away and close your eyes. A mental image of the building should appear in your mind.

3. Begin to translate what you have memorised onto the page.

4. As you practise and get better at this exercise, you can challenge yourself to undertake more detailed subjects. You can consider form, shape, texture, contour, perspective and shadow.

See also:
Shadow Play,
pages 36–37.

Kurt Schwitters built amazing grottoes that he called 'The Merzbauten', constructed solely from found objects. He wandered the streets with a suitcase picking up abandoned and discarded items. He would beg, borrow and sometimes steal objects to include in his incredible creations.

Skippers

Artists often breathe new life into the objects that most people would consider to be of little value. For this exercise, you will have to find treasures among objects thrown out by others in search of inspiration for something to draw. It is the artistic equivalent of upcycling.

1. Find an interesting skip and see if there is anything inside that you want to draw. You can isolate a single object or mix and match several. Alternatively, you might want to draw the complete skip with its contents – the random juxtaposition of objects can be really interesting.

2. You don't have to draw the objects in situ. Remember, though, it's always polite to ask permission to take anything away from a dumpster.

3. Draw the shapes, observing the different perspectives. You can develop areas of tone and shadow to add form and depth to the jumble of shapes.

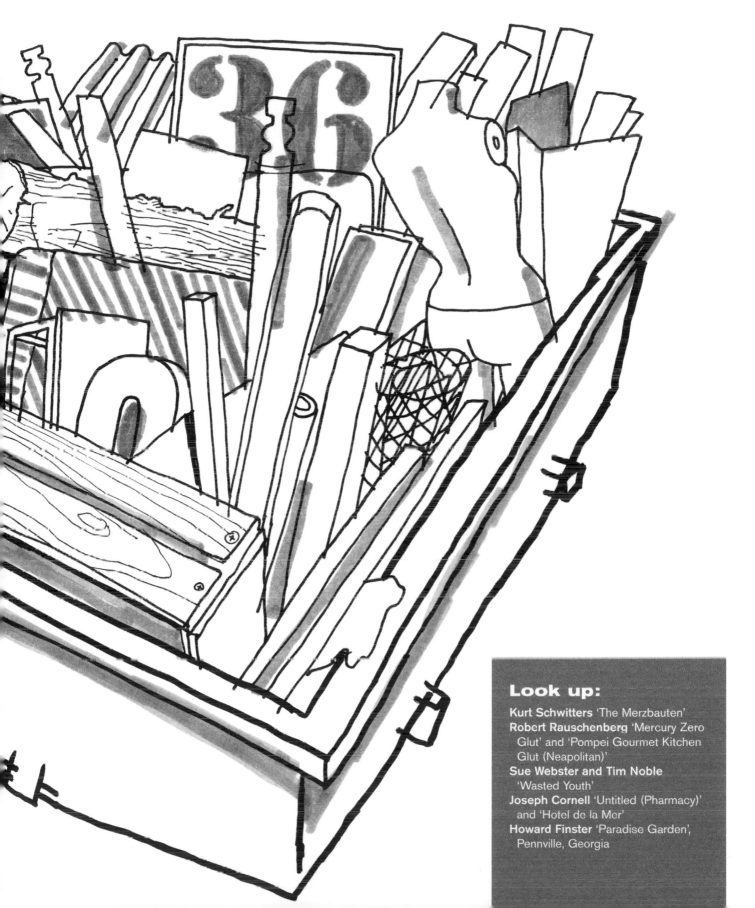

Look up:

Kurt Schwitters 'The Merzbauten'
Robert Rauschenberg 'Mercury Zero
 Glut' and 'Pompei Gourmet Kitchen
 Glut (Neapolitan)'
Sue Webster and Tim Noble
 'Wasted Youth'
Joseph Cornell 'Untitled (Pharmacy)'
 and 'Hotel de la Mer'
Howard Finster 'Paradise Garden',
 Pennville, Georgia

This exercise is primarily about understanding how our binocular vision helps us to see the world from different perspectives.

Turn a Blind Eye

Our eyes are approximately 5cm (2in) apart, and therefore each eye sees the world slightly differently. Both eyes work together in sending messages to our brain, and it is this that enables us to understand depth. Looking at the world in this way helps us to see the world in three dimensions and gives us a much greater field of vision.

1. Stand very still in front of a window. You will need three different coloured felt-tip pens.

2. Keep your right eye closed, or put your hand or an eye-patch over it. It's important that your feet remain in a fixed position.

3. Now draw an outline of what you see outside onto the window with one of the coloured pens. You may find that your eye is struggling to focus as you switch between the drawing on the window and the view outside. By closing one eye, you are able to 'flatten' what you see.

4. Open your eyes, stay in exactly the same position,

and change the pen colour. Draw the same scene again, this time with your left eye closed.

5. Finally, change the pen colour and open both eyes. Now draw the same scene again. Once again you may find this surprisingly difficult, as your binocular vision struggles to recalibrate between your drawing on the window and the subject matter.

6. These out-of-register interpretations will give you an insight into how your binocular vision shapes the drawings that you make. You may now want to close your eyes and lie down in a darkened room!

Look up:
Pablo Picasso 'Tête de Femme'
Georges Braque 'Still Life With Violin'
David Hockney 'Joiners' photomontages

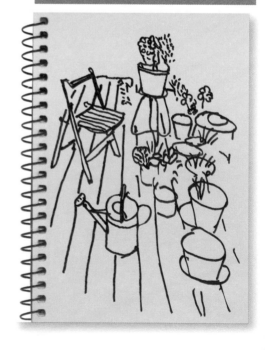

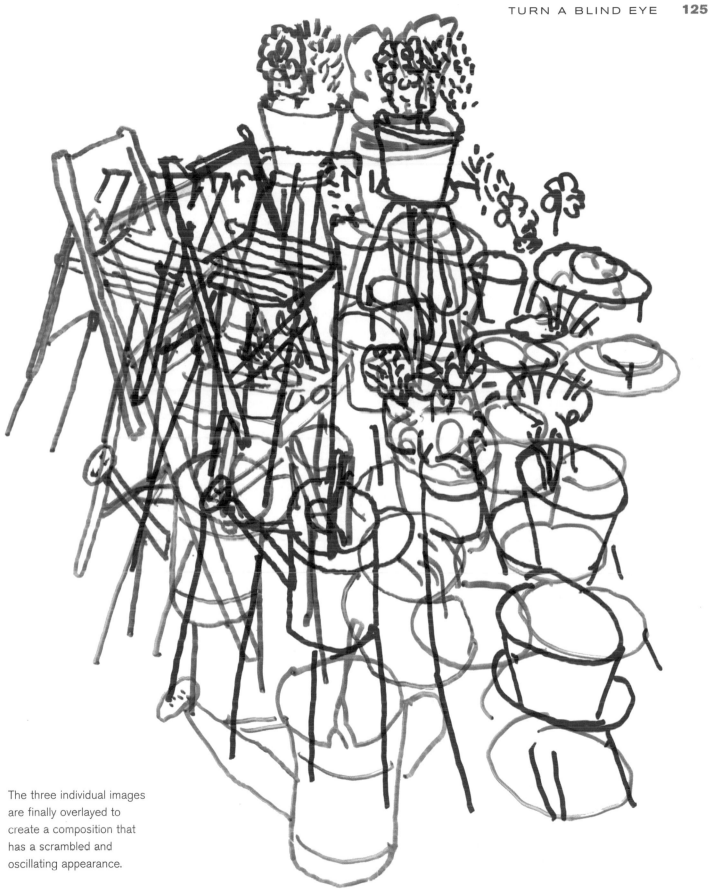

The three individual images
are finally overlayed to
create a composition that
has a scrambled and
oscillating appearance.

See also:
Magnifly, pages
116–117.

Think SMALL

We often overlook the small things in life. Small objects such as screws, nuts, bolts, clips and buttons play understudy to the larger objects that they are placed on, or that they hold together.

This exercise is about celebrating these forgotten objects and placing them centre stage. The process of drawing small objects is very different from drawing larger objects. For a start, you can pick them up and inspect them up-close. Also, the finer details of a small object could be difficult to see with the naked eye, so magnification might be necessary.

Your task is to take a closer look at small objects and draw them. Study their shapes, patterns and forms, and let your drawings grow organically on one sheet of paper.

1. Root around for as many small objects as you can find – things lurking at the bottoms of drawers, in purses or in tool or toy boxes.

2. Use a hard pencil or a fine-line pen and a large sheet of paper.

3. You might decide to use a magnifying glass to explore the details of the objects.

4. Don't worry about drawing the objects in scale with each other; just let the objects sprawl across the piece of paper as you draw them.

Draw with your less dominant hand.

Draw using a cross-hatching technique.

Scribble.

Draw with a ruler.

For this exercise, the die will help you with your creative decisions. You will need to throw caution to the wind and let fate take its course. To be faced with a blank sheet of paper can be incredibly intimidating. Sometimes we need to find mechanisms to trigger our creative impulses.

The Dice Man

John Cage, the musician and artist, relied upon, as he called them, 'chance operations' to determine the outcome of his work. At first, he threw nickels and quarters and followed the rules of the I Ching to control his creative decisions. His series of drypoint etchings called the 'Déreau' were also created using this method. He enjoyed seeing what could happen when he let an outside force govern the direction of his work.

Draw dots.

You are going to create a drawing of a face by combining the separate tasks listed below. The number on the die will dictate the method you use for each task.

Use both hands together to draw.

1. Throw the die. Each number on the die corresponds to the drawing instructions shown left.

2. Combine the tasks on the page to create a face. Draw the eyes, nose, ears, mouth and hair.

3. Feel free to throw the die as many times as you want and continue to develop your drawing. Remember to stick closely to the methods shown.

4. Decide where each of the separate elements are placed and create a unified composition.

5. Each time that you throw the die, you will be opening up a multitude of possibilities. When you decide where the separate elements are placed, you will once again be in control of your creative decisions. The biggest decision that you have to make is when to stop throwing the die!

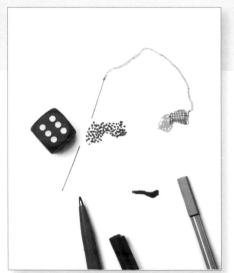

After six throws of the die, the image is beginning to emerge. Cross-hatching, scribbles, dots and ruled lines form the eyes and nose.

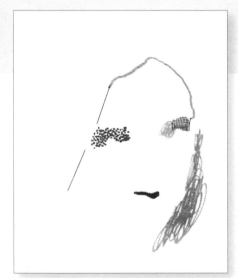

As the die continues to dictate the method, more scribbles form the outline of the face.

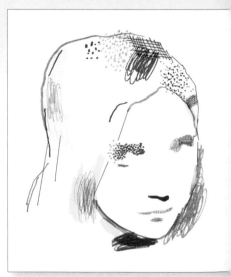

The die rolls on, and even more of the portrait is formed, outlining the features, face and hair.

Look up:

John Cage 'Déreau'
 series
Luke Rhinehart *The
 Dice Man*

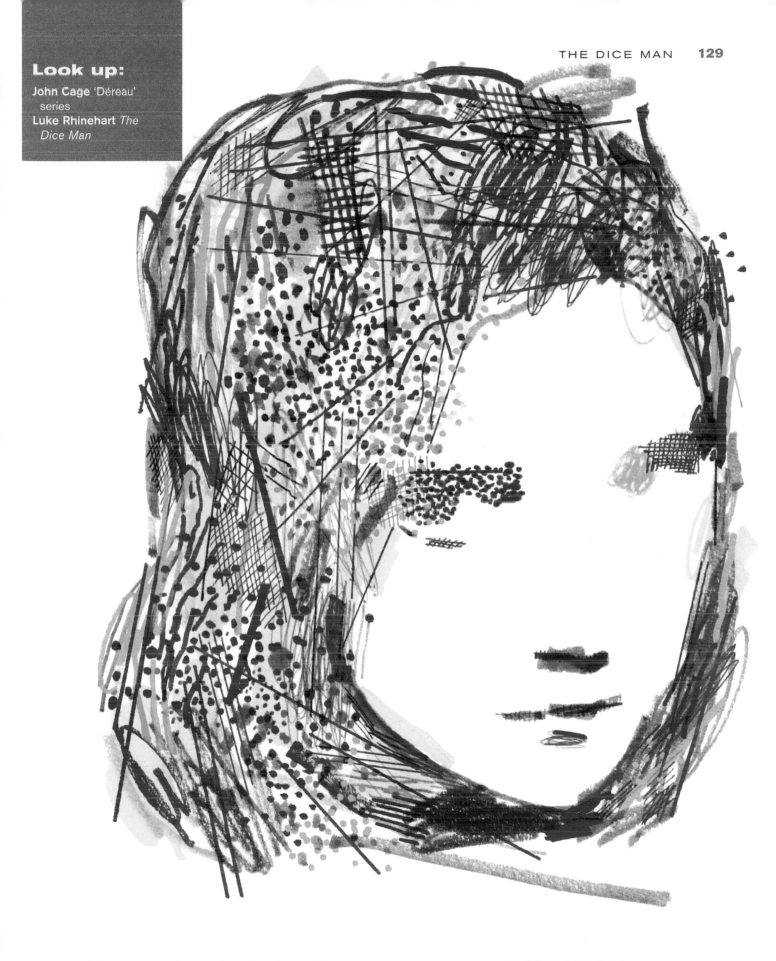

Deface

You are going to subvert and modify the cover image of a magazine using marker pens. This task should be as playful as possible; it's a great way to explore the potential of mixed-media drawing.

Many graffiti artists subvert images appropriated from advertising and the mass media. In the 1990s, the street artist KAWS chose to sabotage the advertising world by reworking and modifying ads on billboards, bus shelters and phone boxes. He adapted posters by introducing cartoon characters painted with crosses to replace their eyes. His intention was to trick the onlooker into believing that the subverted image was all part of the original advertising campaign. Here you are going to reinvent and adapt a cover image.

1. Look in your recycling bin for a discarded magazine.

2. Use a selection of coloured permanent marker pens, as these will sit well on either a glossy or a matt cover.

3. Your drawing should interact with and respond to the cover image. For example, it might be a satirical or scathing attack on the retouching that is employed on most fashion magazine covers these days, wiping the smile off a film star or politician, or it could be a surreal interpretation of the cover image.

4. You can be as destructive as you like. You have licence to distort, disfigure and erase with impunity.

Look up:

KAWS 'Nylon' magazine cover, February 2001
Kurt Schwitters 'Carnival'
Francis Bacon 'Pope I – Study after Pope Innocent X by Velázquez'
Jamie Reid 'God Save the Queen' cover artwork
Dr. Lakra 'Sin Título/Untitled (Sillón Rojo)'

From wrinkles to tribal tattoos, and from hearts to hippies, you can really let your creativity flow.

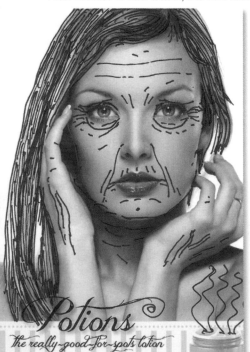

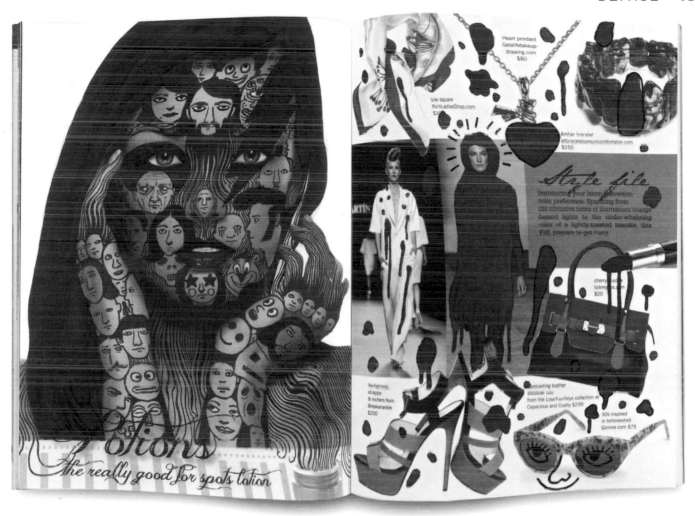

Try using other materials you have to hand: biros, paint and even Tipp-Ex can all be used to create different effects.

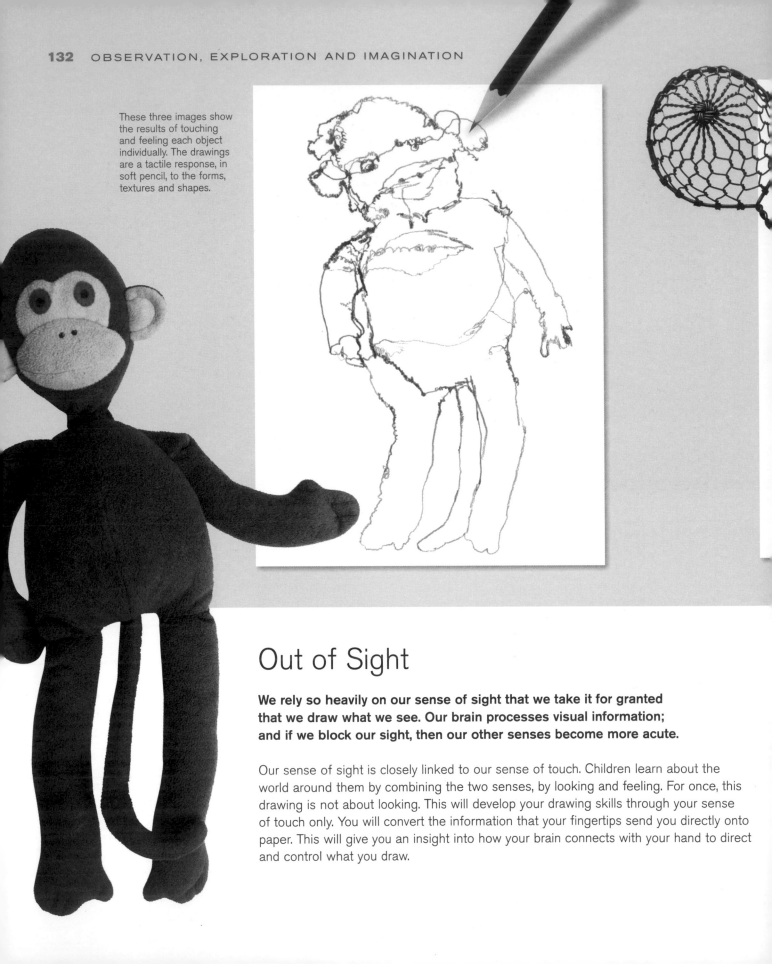

These three images show the results of touching and feeling each object individually. The drawings are a tactile response, in soft pencil, to the forms, textures and shapes.

Out of Sight

We rely so heavily on our sense of sight that we take it for granted that we draw what we see. Our brain processes visual information; and if we block our sight, then our other senses become more acute.

Our sense of sight is closely linked to our sense of touch. Children learn about the world around them by combining the two senses, by looking and feeling. For once, this drawing is not about looking. This will develop your drawing skills through your sense of touch only. You will convert the information that your fingertips send you directly onto paper. This will give you an insight into how your brain connects with your hand to direct and control what you draw.

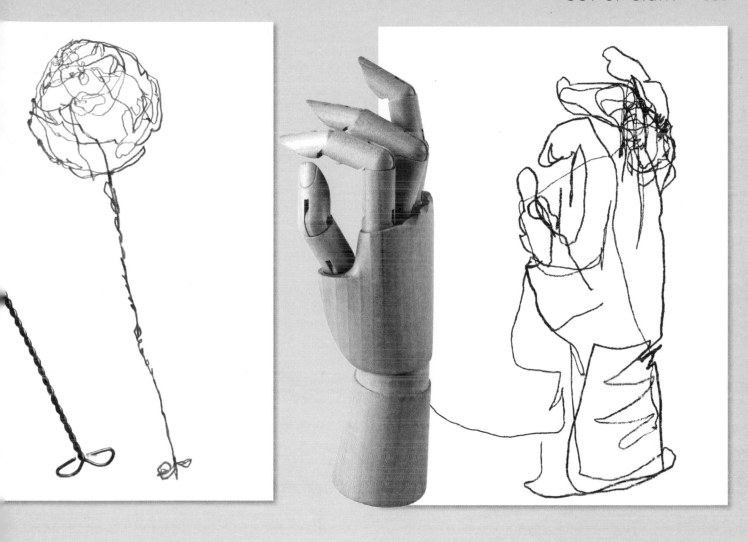

1. Ask a friend to find an interesting object. It could be a natural or man-made form, but the friend must not reveal what the object is to you.

2. Place a large sheet of paper on a wall and set up a table adjacent to the paper.

3. Use a soft pencil, charcoal pencil or pen.

4. Sit at arm's length from the wall.

5. Close your eyes. No cheating!

6. Ask your friend to place the object on the table so that you are able to connect with it.

7. Touch your object for about 5 minutes. Is it hard, soft, spiky or smooth? Does it curve or has it got sharp edges?

8. Start to translate exactly what it feels like onto the page in front of you. Transcribe everything that you feel. Remember that you are merely reproducing what your sense of touch dictates.

9. When you feel that you have drawn the entire contour of your object, open your eyes and all will be revealed.

10. Analyse the image you have made of your secret object. It doesn't matter if it bears little resemblance to the real thing. That you responded through touch alone will probably have resulted in an abstract effect.

'I picked up my sketchbooks daily, saying to myself: "What will I learn of myself that I didn't know?" And when it isn't me anymore who is talking but the drawings I made, and when they escape and mock me, then I know I've achieved my goal.'

Je Suis le Cahier
[I Am the Sketchbook]
by Picasso

I Am the Sketchbook

Picasso understood the importance of keeping a sketchbook as a source of self-discovery and inspiration. The discipline of drawing in a sketchbook every day will help you to become more observant, reflective and analytical. Apart from giving you a visual record of your life experiences, it will also help you to fine-tune your drawing skills.

Sketching can be a very personal and liberating experience. Persevere and it will become an effortless part of your life. Keep it going and the rewards will be enormous; you won't want to give it up. Take your sketchbook and some drawing materials and get out there.

1. Find a sketchbook that you feel comfortable taking with you everywhere. Size matters! There is no point in buying an unwieldy sketchbook that is too cumbersome to lug around.

2. Carry with you a selection of drawing materials, including pens, pencils, erasers and a sharpener. However, if you're caught short, even a cheap biro will do.

3. Make an entry in your sketchbook every day. Draw things that you see at home, but also try to get out and about to document the unfamiliar.

4. Challenge yourself. Fill your sketchbook with things that you haven't drawn before. Don't be reticent with your drawings – feel free to make mistakes. You will learn from them. The only way to progress is to explore and experiment; you will soon see a great improvement in your work.

Look up:

Pablo Picasso
Je Suis le Cahier
Georges Seurat Sketchbooks at the Museum of Modern Art, New York
J.M.W. Turner Collection of sketchbooks at the Tate, London

Continued on the next page

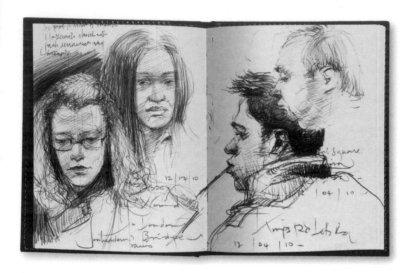

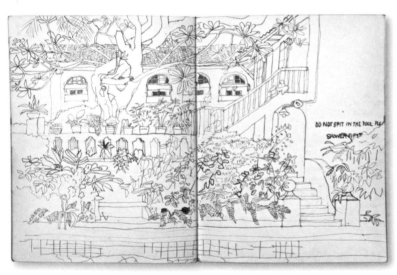

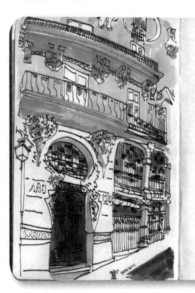

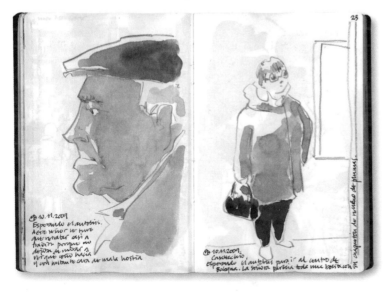

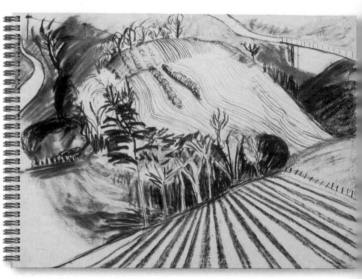

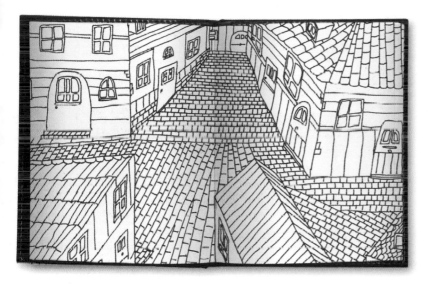

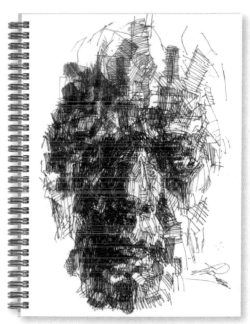

The sketchbooks on these pages will begin to give you an idea of the myriad ways you can explore and develop your drawing skills by sketching. We can see an intricate line drawing contrasting the softness of foliage with the geometric lines of buildings, and sketches of cobbled streets and an interior that explore the rules of perspective. Landscapes can be handled like the expressive rolling hills that guide your eye around the page, or in the isolated use of colour that pulls your focus into the valley. Detailed portrait studies, atmospheric colour drawings and strong sculptural drawings chiselled using cross-hatching explore the human form. Your sketchbook could even take a digital form using some of the amazing drawing programs and apps that are available, as seen in the simple line drawing created on an ipad.

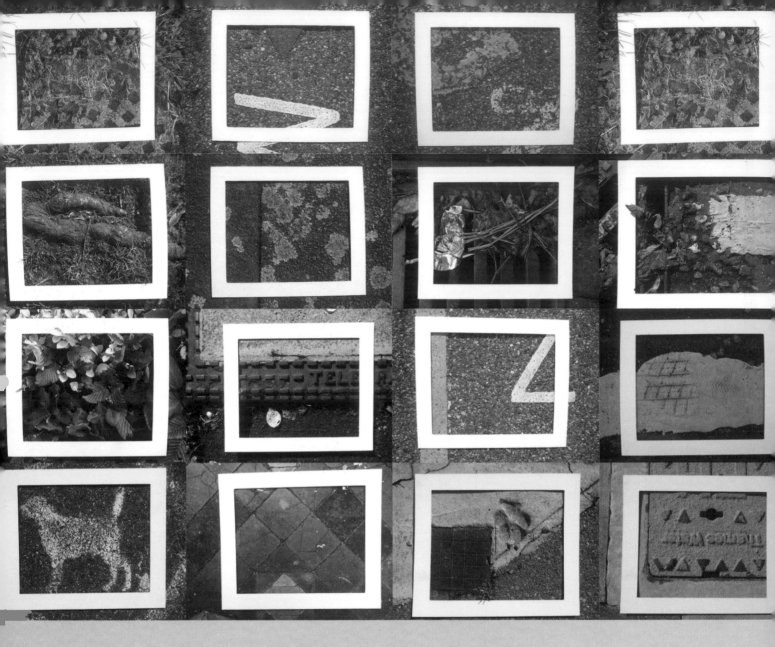

Mapping Your World

The Boyle Family is made up of artists who collaborate to re-create and document very specific locations chosen at random.

Mark Boyle and Joan Hills initiated 'The World Series' in 1968 by asking blindfolded participants to either throw a dart or fire an air rifle at a map of the world. One thousand sites were selected from the punctured map. They pinpointed each area as closely as possible and tracked it down. They then threw a right-angled piece of metal up into the air and where it landed determined the 2-m (6-ft) square surface area that they would document with archaeological accuracy. They scrupulously reproduced what they found as three-dimensional fibreglass reliefs. Mark and Joan's two children joined the project to help them to complete this Herculean task. Their studies included casts of concrete curbs, sandy beaches, tarmac roads, tiled entrances and exposed brick floors, for example. They were especially interested in reconstructing the textured surface of each section.

You are going to take inspiration from a randomly selected area. Look at the textures and patterns that you find and represent them in a textural drawing.

The frame surrounds a work glove abandoned on a pebble background.

First, a graphite stick rubbing is taken of the glove itself.

An outline of the glove is drawn over the rubbing using a charcoal pencil.

Another graphite rubbing is taken, this time of the pebble texture.

Finally, the image is enhanced with a coloured crayon.

This selection shows a plastic, patterned frame embedded into a rough, muddy surface.

An outline of the pattern is drawn in charcoal pencil.

The image is placed over a rough texture and a rubbing is taken with a coloured crayon.

The textures build up with the addition of another rubbing.

Finally, the leaf and plastic pattern are defined with coloured pencils.

1. Wear a blindfold and put a pin in a map of your local area.

2. Establish exactly where your pin is placed and visit the location. If the spot is too difficult or dangerous to access, then go through the process again until you find a suitable site.

3. Cut a frame out of a sheet of white card and place it on the ground as close to your location as possible.

4. Study your selected area and take inspiration from what you see in terms of texture and pattern. Does it have a rough or grainy surface? Are there contrasting patterns and surface qualities?

5. You can use a graphite stick to take rubbings from different surfaces (bubble wrap, crumpled paper, sandpaper, etc.) to help you describe your location.

6. Try using graphite powder rubbed on with absorbent cotton, or applied with an old toothbrush for soft tones, or even sprinkled on like pepper. You might want to 'draw' with your fingers by dipping them in the graphite powder and then making marks on the page.

7. Use a range of drawn marks to enhance your picture: stippling, hatching, cross-hatching, etc.

Look up:

The Boyle Family 'The World Series'
Frank Auerbach 'Rebuilding the Empire Cinema, Leicester Square'
Jackson Pollock 'No. 5'
Lucio Fontana 'Concetto Spaziale, Attese'
Antoni Tàpies Matter paintings

There are those conventional purists who believe that technology should be avoided at all costs – and there are also others who fully embrace it. It is important to grow as an artist by taking inspiration from every new opportunity that technology introduces.

Flower Power

The artist David Hockney has always embraced new technological advances and has often used them in his work. He extends the boundaries of drawing to their limits by utilising colour photocopiers, cameras, fax machines and computers. He exhibited a series of Polaroid 'joiner' photomontages under the title of 'Drawing with My Camera'.

An artistic predecessor, Henry Fox Talbot, also appreciated the connection between art and technology. He discovered a photographic technique using paper coated with a light-sensitive chemical, and created unprecedented images of leaves, lace and other flat objects.

His 'photogenic drawings' were, he believed, a natural extension of drawing. He wrote a book that detailed his experiments entitled *The Pencil of Nature*.

For this exercise, you are going to take inspiration from Fox Talbot's innovative images. You are going to engage with technology to inform your drawing, using as many experimental mediums as possible. This will help you to generate original and diverse work.

1. Go out for a walk and collect some flowers or leaves.

2. Scan and print them out (or photocopy them).

3. Work on top of your print with any other media you feel appropriate, such as pen, pencil, charcoal or ink.

4. This method is one way of using technology to explore and develop your drawing style.

A rhododendron is scanned in colour after being pressed down.

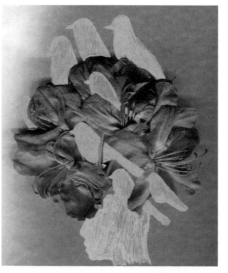

The scanned image is printed out onto heavyweight paper. Thick, water-based pens are applied to the surface of the print.

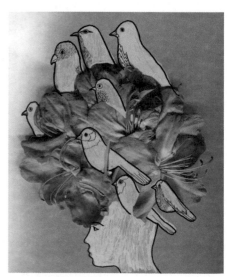

Outlines are created using black marker pens.

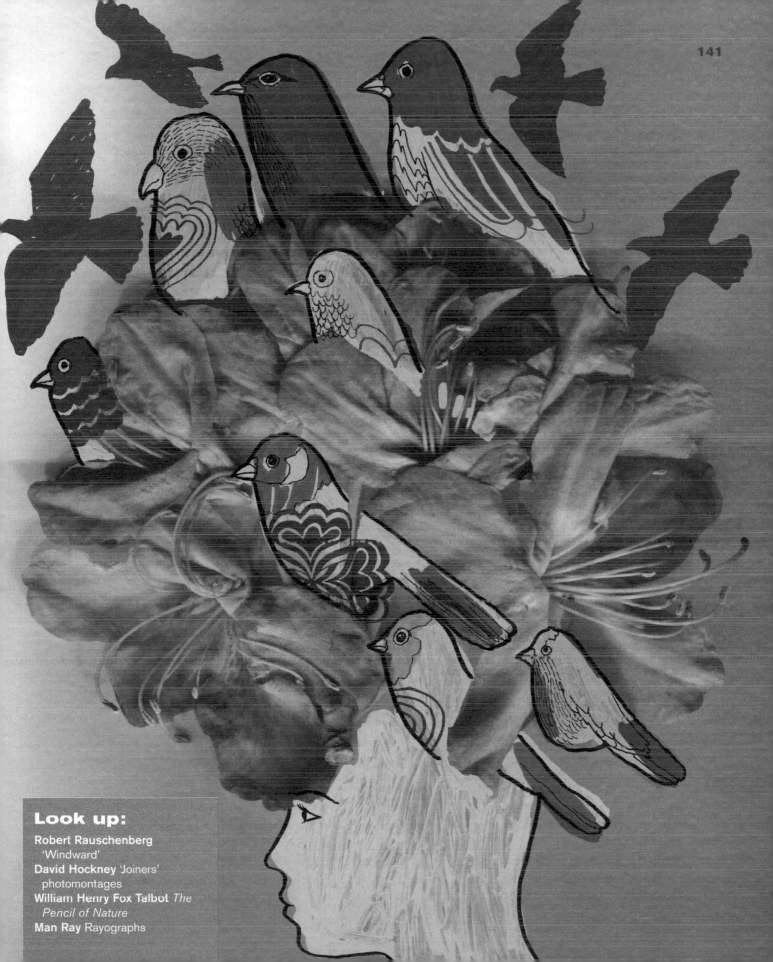

Look up:

Robert Rauschenberg
 'Windward'
David Hockney 'Joiners'
 photomontages
William Henry Fox Talbot *The Pencil of Nature*
Man Ray Rayographs

'All human beings are also dream beings. Dreaming ties all mankind together.'

Jack Kerouac

Last Night I Had the Strangest Dream

The unconscious dream state has inspired musicians, writers, artists, scientists and academics throughout history. Dreams can reveal truths and throw light on reality itself. They are often the catalyst for the production of imaginative and original works.

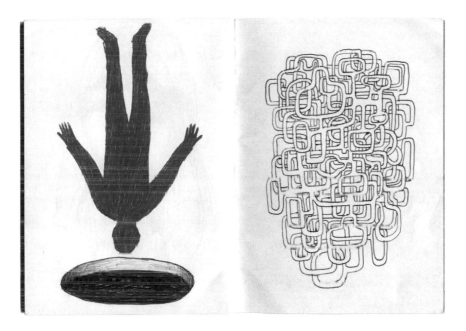

The Surrealist painter Salvador Dalí based his work on the perception of his own dreams; he was influenced by Sigmund Freud's psychoanalysis of the unconscious mind. Dalí used a highly realistic and symbolic technique to convey the psychological meaning of the dreams on canvas. 'The Persistence of Memory' in which he depicts soft melting watches draped across a barren landscape represents the blurred division between fantasy and reality.

This exercise will help you explore your own subconscious mind and develop your imagination.

1. Keep a sketchbook and pen by your bed.

2. As soon as you wake up, draw any dream imagery or subconscious thoughts you had while asleep.

3. Try to convey the emotional and visual characteristics of your dreams on the page.

4. The drawings may be literal depictions or expressive, abstract interpretations.

Look up: Salvador Dalí 'The Persistence of Memory', **Marc Chagall** 'The Dream', **Frida Khalo** 'Without Hope', **Odilon Redon** 'Cactus Man' and **Alfred Hitchcock and Salvador Dalí** Dream sequence in 'Spellbound'

Keeping it Regular

It is estimated that we spend an average of 1 hour and 42 minutes every week on the loo. Sadly, sitting on the toilet can sometimes be our only opportunity to take time out from our hectic lives.

Many people have reading material in their bathrooms and use it as a time for quiet contemplation. It can also be the ideal moment for generating ideas and releasing any imaginative visions onto the page.

1. Keep a sketchbook and pen accessible in your bathroom.

2. Sketching outdoors can be quite an intimidating experience for a novice, as it often draws the attention of passersby. (Or it can be a pleasant experience – most people who are interested in taking a peek are complimentary.) However, the sketches for this task can be made in the privacy of your own bathroom, with the door locked and out of the gaze of anyone else! Don't be reticent about what you draw. There is nobody looking over your shoulder to judge you, so anything goes!

3. You probably won't have the time to draw things in great detail; but if you want, you can make a more involved drawing in stages.

4. Make a habit of adding something to your sketchbook on each visit. Like everything in life, practice makes perfect. The most important thing is that you keep it regular!

See also: Hanging on the Telephone, pages 108–109.

Little Black Book

Our emotions can and often do influence our creative output. One case in point is the eighteenth-century Spanish painter Francisco Goya, who chose to reveal the dark side of his personality through his paintings and drawings.

Goya's health began to fail towards the end of his life. He managed to overcome two near-fatal illnesses and became almost totally deaf. Goya moved to a house that was (somewhat ironically) named Quinta del Sordo (Deaf Man's Villa). These events, added to the political turmoil in Spain, led him to fall into a serious depression, and he began to produce a series of extremely haunting works known as the 'Black Paintings'. Goya worked directly on the walls of the villa itself and painted harrowing scenes of cannibalism, witchcraft and devils. These gloomy, bleak visions were

perhaps an attempt for him to dispel his worst fears and anxieties.

Drawing can often be a cathartic and therapeutic experience. A visual outpouring of emotion can become a window to the imagination and an inspiration in itself. Keep a book solely in which to make drawings of all the anger and turmoil in your life. This book will act as a creative release valve for these negative emotions.

Look up:

Francisco Goya 'Black Paintings'
Jake and Dinos Chapman 'Hellscapes'
Hieronymus Bosch 'The Garden of Earthly Delights'
Edvard Munch 'The Scream'
Odilon Redon 'The Cyclops'

I Shop, Therefore I Draw

Don't write yet another shopping list: draw each item instead. This is a mental image task that requires you to retrieve information visually.

When you draw something from your memory, you are not only fortifying your memory but also strengthening your drawing skills.
 Making images in your 'mind's eye' will help you to see things more clearly when you draw objects from life.

1. Think about each individual item, and then draw it from your imagination.

2. Draw each item in succession on the page. You can draw these items as a list in a line, or have fun with overlapping the shapes to make a composition.

3. You could even work them up into fully rendered versions (see next pages).

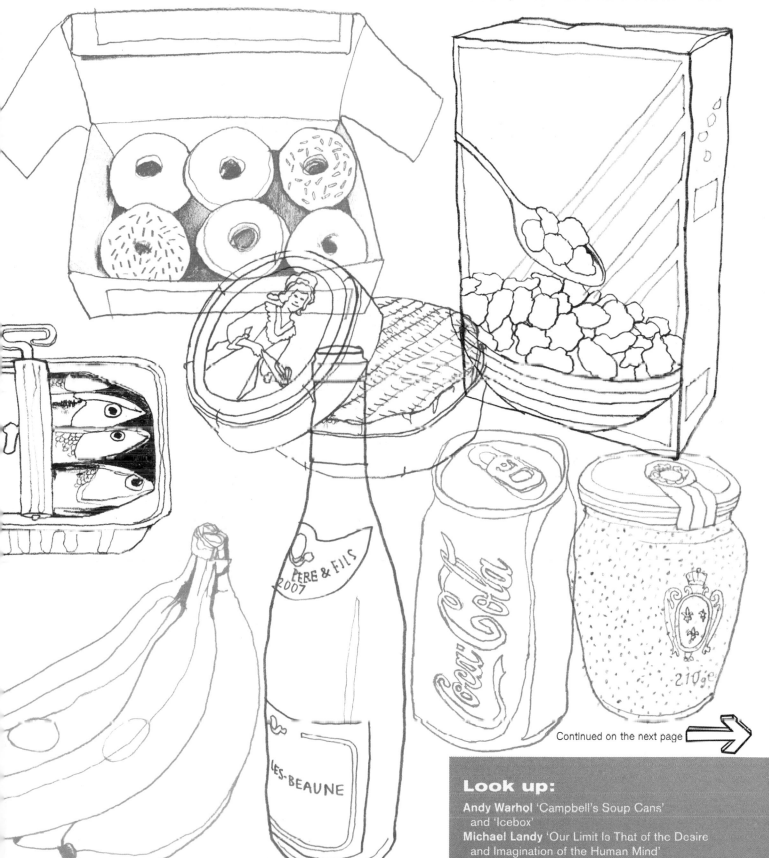

Continued on the next page ➡

Look up:

Andy Warhol 'Campbell's Soup Cans'
and 'Icebox'
Michael Landy 'Our Limit Is That of the Desire
and Imagination of the Human Mind'

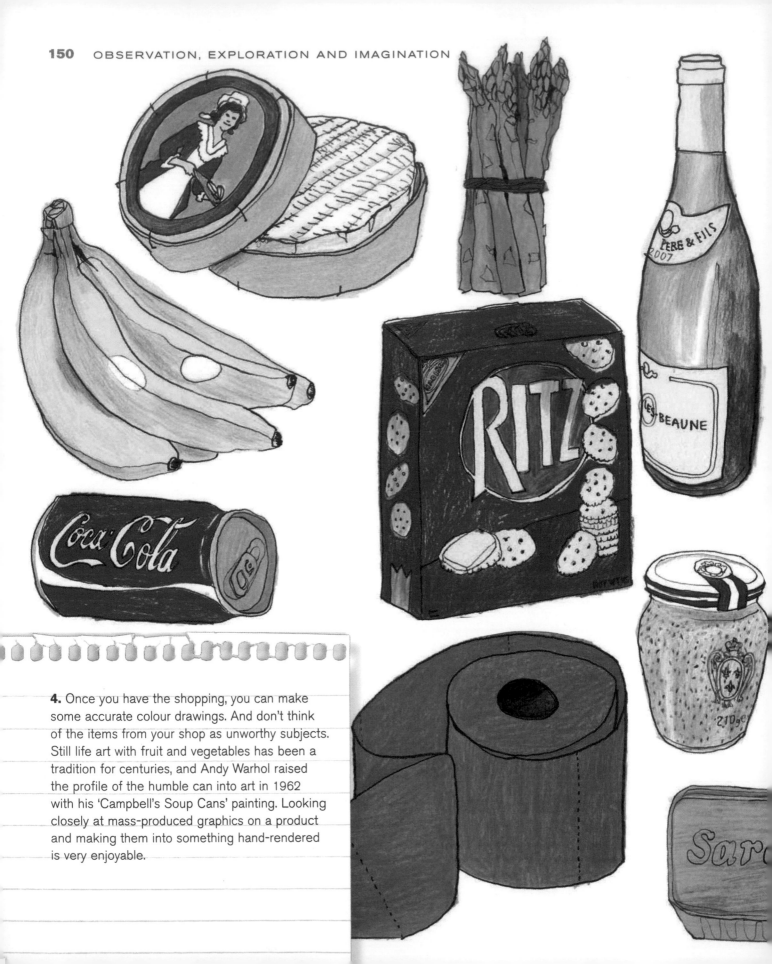

4. Once you have the shopping, you can make some accurate colour drawings. And don't think of the items from your shop as unworthy subjects. Still life art with fruit and vegetables has been a tradition for centuries, and Andy Warhol raised the profile of the humble can into art in 1962 with his 'Campbell's Soup Cans' painting. Looking closely at mass-produced graphics on a product and making them into something hand-rendered is very enjoyable.

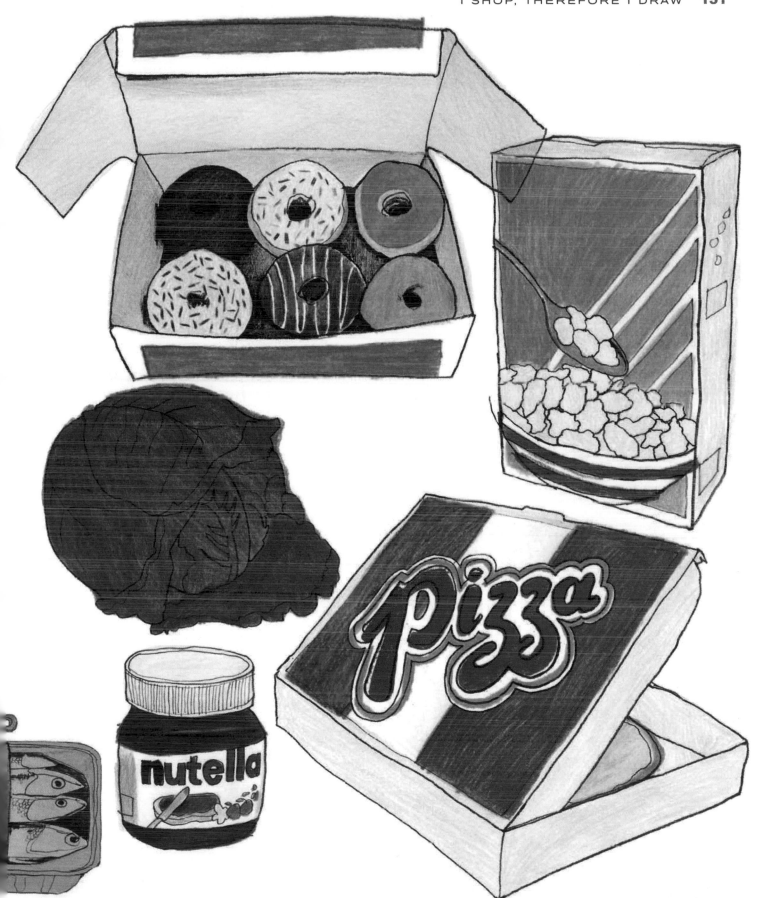

Sometimes we need to find devices to stimulate our creativity. For instance, Leonardo da Vinci would stare at the stains on his wall and see 'mountains, ruins, rocks, woods, great plains, hills and valleys in great variety'.

Blot on the Landscape

The artist Andrea Mantegna recognised human faces in the clouds. He was able, through the power of projection, to represent his own imaginative ideas. Ink blots are unpredictable and will give you a starting point that will take you on an imaginative journey. Make your own blots and let the marks evolve into spontaneous expressions.

Squirt your ink from a height to get an interesting effect!

1. Take some water-based or Indian ink.

2. Load up a pipette or a squeezy bottle with the ink.

3. From a height or at a distance, take aim – and FIRE!

4. Scrutinise the stains and shapes. What do they look like or remind you of? Make drawings using these blots as a starting point. Interpret them in your own way and develop them on the page.

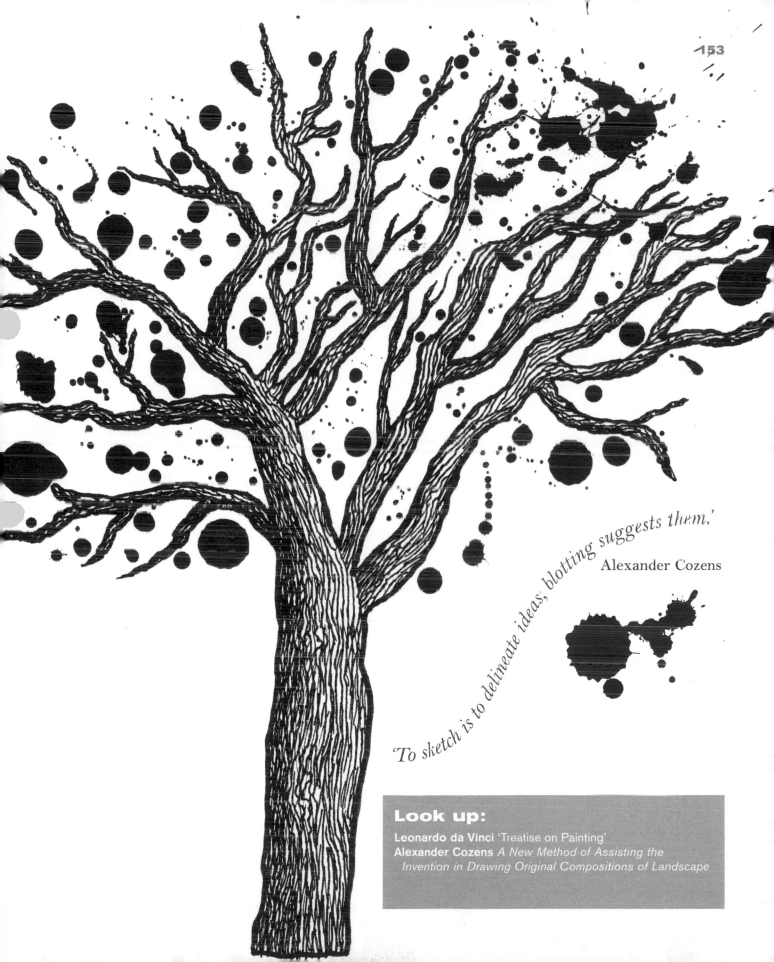

'To sketch is to delineate ideas; blotting suggests them.'

Alexander Cozens

Look up:

Leonardo da Vinci 'Treatise on Painting'
Alexander Cozens *A New Method of Assisting the
Invention in Drawing Original Compositions of Landscape*

Exquisite Corpse

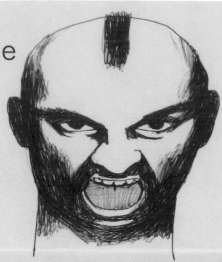

Here we are going to play the Surrealist game 'exquisite corpse' (*cadavre exquis*). It began in Paris and included as participants the Surrealists Marcel Duchamp, Yves Tanguy, Benjamin Péret, Pierre Reverdy and André Breton.

1. You will need two other artists for this task. Find a sheet of paper that can be folded into three sections and some pens.

2. Within the top third of the paper, one of you must draw an image of a head without the others seeing. The face could be that of an animal or even an otherworldly alien. It's completely up to you.

The game involves each player writing a phrase on a sheet of paper and then folding the paper into a concertina to hide part of it. The next participant then passes the sheet on to collect another offering. After a succession of contributions, the assembled phrases are finally revealed. (Max Ernst called it 'mental contagion'.) The game naturally progresses from storytelling and poetry to drawings and collage. Parts of the body are drawn and joined together: the head of a person or an animal, then the torso and last of all the legs, to form a composite character. Jake and Dinos Chapman made etchings closely following the rules of the 'exquisite corpse'. Their etchings helped to reinforce their own surreal dialogue as artistic collaborators, and they created a series of imaginative, grotesque and idiosyncratic characters.

This exercise can reveal some bizarre and unpredictable juxtapositions, which can be used as a source of inspiration. The sociable nature of this exercise can be a welcome break from making work on your own. However, most importantly, it's a lot of fun and can often throw up some hilarious results.

3. Now, fold back your image so that all that can be seen is the very bottom of the head – the neck lines – and pass it on to the second artist.

4. The next stage is the torso. When this is completed, the paper is once again folded back, leaving a small indication of the edge of the drawing so that the image can be continued.

5. Finally, the next participant completes the exercise by drawing the legs and feet.

6. After the legs are finished, the image can be unfolded to reveal the entire drawing.

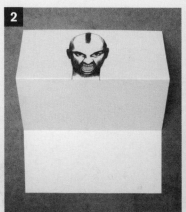

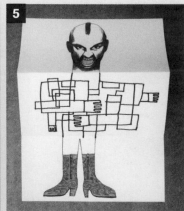

Look up:

Surrealists Marcel Duchamp, Yves Tanguy, Benjamin Péret, Pierre Reverdy and André Breton
Jake and Dinos Chapman 'Exquisite Corpse' series

Glossary

Abstract art Type of art in which the artist relies on colour and form instead of choosing to portray the subject in a realistic or naturalistic way.

Abstraction Reduction or simplification of an image or object to an essential aspect of its form or content.

Axonometric An objective three-dimensional representation that combines plan and elevation information on a single, abstract drawing. It depicts a view that cannot be perceived in real space. It is measured along three axes in three dimensions, at an angle of 45 degrees from the plane of projection. Its ease of construction is due to the fact that parallel lines remain parallel.

Bird's-eye view An elevated view of an object or scene from above, as if seen by a bird in flight. The opposite of worm's-eye view.

Blocking in Initial application of mass of medium representing the division of area into a value pattern.

Cadavre exquis Also called Exquisite Corpse. A Surrealist group game in which a story or picture is collaboratively constructed. Each player makes a contribution by being allowed to view only the very end of what the previous player has added.

Cast shadow The shadow thrown by a form onto an adjacent or nearby surface in a direction away from the light source.

Charcoal Black pigment consisting of a burned or charred substance, reduced to a porous form of carbon.

Chiaroscuro An Italian word (meaning "light-dark") referring to the modelling of volume by depicting light and shade by contrasting them boldly. This is one means of strengthening an illusion of depth on a two-dimensional surface, and was an important topic among artists of the Renaissance.

Collage Technique of forming a picture by pasting any suitable materials (pieces of paper, photos, news cuttings, fabrics) onto a flat surface.

Composition The arrangement and combination of elements in a picture.

Conté crayon Mixture of graphite and clay, invented by Nicolas-Jaques Conté in 1795. Conté crayons are thinner and harder than traditional pastels. This hardness allows for crisp, detailed drawing techniques when used on its tip, and the coverage or shading of large areas when used on its side.

Cropping The cutting out or exclusion of extraneous parts of an image to show only the portion desired or to fit a given space requirement.

Cross-hatching Technique for building up areas of shadow with layers of criss-cross lines instead of solid tone.

Cubism Art style developed in 1908 by Picasso and Braque whereby the artist breaks down natural forms into geometric shapes and creates a new kind of pictorial space. Unlike traditional styles, where the perspective is fixed and complete, Cubist works portray a subject from multiple perspectives.

Expressionism Art movement of the early twentieth century in which adherence to realism and proportion was replaced by the artist's emotional connection to the subject. These paintings are often abstract, the subject distorted in colour and form to emphasise and express the intense emotion of the artist.

Focal point An area or element that dominates a drawing; the area to which the viewer's eye is most compellingly drawn.

Form The volume and shape of a three-dimensional work.

Form shadow The less defined, dark side of an object. Usually the side that is not facing the light source.

Frottage Technique in which a piece of paper is placed over a textured or indented surface and rubbed over with a soft pencil, crayon or pastel stick. Designs or textures created in this way are often used in collage work.

Futurists Italian artistic and social movement that flourished in 1909 when Filippo Tommaso Marinetti published his manifesto of futurism. The futurists portrayed the dynamic character of early twentieth century life, glorified war and industrialisation, and took speed, modernity and technology as their inspiration.

Golden section System of organising the geometrical proportions of a composition to create a harmonious effect. Known since ancient times, it is defined as a line divided in such a way that the smaller part is to the larger part what the larger part is to the whole.

Grade (of pencil) Relative hardness or softness of the carbon contained in a pencil by degree. Indicated by letters, numbers or symbols.

Graduation Gradual progression of tones, from dark to light or light to dark. In drawing, graduated shading is used to suggest three-dimensions.

Hatching Shading technique of using parallel lines to indicate form, tone or shadow.

Highlights Identifies the brightest areas of a form where light bounces off its surface. Usually the area closest to the light source.

Horizon line Imaginary line that stretches the subject at your eye level, and where the vanishing point or points are located. The horizon line in perspective should not be confused with the line where the land meets the sky, which may be considerably higher or lower than your eye level.

Impressionism Late-nineteenth-century French style that opted for a naturalistic approach using broken colour to depict the atmospheric and transforming effects of light. It is characterised by short brushstrokes of bright colours that recreate visual impressions of the subject and capture the light, climate and atmosphere at a specific moment.

Indian ink A simple black ink commonly used for drawing that was once widely used for writing and printing.

Inverse perspective Technique whereby the lines of perspective separate rather than converge on the horizon line. Also called Reverse Perspective, it gives the impression of the subjects coming out of the drawing towards the viewer.

Isometric A type of technical drawing with a lower-angle view than axonometric projections, at 30 degrees from the plane of projection.

Linear perspective (*see* Perspective) Technique based on the principle that receding parallel lines appear to converge on the horizon line.

Medium Type of material one works with, such as pencil, pen, charcoal, etc.

Mixed-media Technique of using two or more established media in the same picture.

Monochrome Of one colour, chroma or hue.

Negative space Drawing the space around an object rather than the object itself.

One-point perspective A type of perspective construction with a single vanishing point.

Perspective Systems of representation in drawing that create an impression of depth, solidity and spatial recession on a flat surface.

Pigment Raw substance of colour. Each pigment has its own origin, be it an earth mineral or organic substance. Paint is made from pigment mixed with a medium.

Plane of projection This is the flat physical surface of the drawing. To create the illusion of depth in a drawing, most of the elements appear to recede from this plane.

Pointillism Technique of applying colour in dots rather than in strokes or flat areas. Developed by George Seurat, this technique is sometimes called Divisionism or Neo-Impressionism.

Portrait An up-close study of a person, animal or flower. Implies a degree or accuracy and formality.

Post Impressionism French movement that was both an extension of Impressionism and a rejection of its limitations. While owing a debt to Impressionism for its freedom from traditional subject matter, the Post Impressionists rejected the objective recording of nature in terms of the underlying effects of colour and light in favour of more ambitious expression.

Proportion The compositional relationship between parts.

Rule of thirds Division of an area by thirds, vertically and horizontally. To place your centre of interest at any one of the four intersections is considered to be advantageous.

Rule of odds Compositional term suggesting that images are most visually appealing when they contain an arrangement of an odd number of objects.

Shading The process of adding tone to a drawing so as to create the illusion of texture, form and three-dimensional space.

Still life Piece of art featuring an arrangement of inanimate objects. Traditionally objects were selected for their symbolic meanings.

Stippling Pattern of dots created either individually with a pencil point, pen-and-ink nib or scratchboard knife; or dots created with blunt paintbrush bristles dipped into paint and applied perpendicularly to the page in an up-and-down motion.

Surrealism Developed in 1920s Europe, a style of art characterised by the use of the subconscious as a source of creativity to liberate pictorial subjects and ideas. Surrealist artists often depict unexpected or irrational objects in an atmosphere of fantasy, creating a dream-like scenario.

Tone Also known as value, the lightness or darkness of any area of the subject, regardless of its colour. Tone is only related to colour in that some hues are naturally lighter than others. Yellow is always light in tone whereas purple is always dark.

Two-point perspective A perspective construction with two vanishing points. A way of representing space in which physically parallel elements of the same size appear progressively reduced along converging rays to the left and right, reaching a single point on the horizon on both the left and right sides.

Vanishing point In linear perspective, the point on the horizon line at which receding parallel lines meet.

Viewfinder An adjustable frame which allows artists to examine a potential subject from various viewpoints to plan a composition.

Viewpoint The angle at which an image is represented to provide the best aesthetic study or to emphasise particular elements in the composition.

Worm's-eye view A view of an object from below or from a low viewpoint, as if seen by a worm on the ground. The opposite of bird's-eye view.

Resources

WEBSITES

www.artforum.com

www.artrabbit.com

www.campaignfordrawing.org

www.drawn.ca

www.drawingcenter.org

www.drawingroom.org.uk

everypersoninnewyork.blogspot.com

www.moma.org

www.tate.org.uk

BOOKS

Campanario, Gabriel, *The Art of Urban Sketching: Drawing on Location around the World*

de Zegher, Catherine and Cornelia Butler, *On Line: Drawing through the Twentieth Century*

Dexter, Emma, *Vitamin D: New Perspectives in Drawing*

Edwards, Betty, *The New Drawing on the Right Side of the Brain*

Gombrich, E. H., *Art and Illusion*

Gregory, Danny, *The Creative License: Giving Yourself Permission To Be the Artist You Truly Are*

Hanson, Dian and Robert Crumb, *Robert Crumb: The Sketchbooks 1981–2012, 6 Vol.*

Heller, Steven and Talarico Lita, *Typography Sketchbooks*

Hoptman, Laura J., *Drawing Now: Eight Propositions*

Mariscal, Javier, *Drawing Life*

Mitchinson, David, *Henry Moore: Unpublished Drawings*

Nicolaides, Kimon, *The Natural Way to Draw*

Pericoli, Matteo and Paul Goldberger, *Manhattan Unfurled*

Rowell, Margit and Cornelia Butler, *Cotton Puffs, Q-Tips, Smoke and Mirrors: The Drawings of Ed Ruscha*

Index

Credits

© RIA Novosti/Alamy, Kandinsky: ©ADAGP, Paris and DACS, London 2012, p.13

© SIAE, Rome/Corbis, Morandi: © DACS 2012, p.57br

Alade, Adebanji, www.adebanjialade.co.uk, p.96

Anatoli Styf/Shutterstock, p.75tcr

Anweber/Shutterstock, p.75tr

Bearvader/Shutterstock, p.74tc

Bowe, Josh, www.artbyjoshbowe.com, p.97bl, 137tr, 137cr

Bramley, Kate, www.k-eight.co.uk, p.131bl/bc

Clinch, Moira, pp.16-17, 26, 45, 56, 96bl, 97br, 130bl, 131br, 136cl, 137cl

Daniel Pradilla/Shutterstock, p.75tcl

Denevan, Jim, Photo: Peter Hinson, www.peterhinson.com, p.20-21b

eBoy, p.80b

Frajbis, Kath, www.kathfrajbis.com, p.136br

Guerrero, Christian, http://www.lib.berkeley.edu/autobiography/cguerrer/, p.136tr, 137tl

Herranz, Miguel, pp.136cr, 136bl

Jason.Lee/Shutterstock, p.72tr

Joanna Wnuk, p.12b; Andersphoto, p.18bl; Picsfive, pp.37r, 47b, 58b; Milos Luzanin, p.42t; Alexkar08, p.42b; Africa Studio, p.55c; SmileStudio, p.68l; Pashabo, p.106bl; BonD80, p.107bl; Denis Vrublevski, p.116; Pics4sale, p.124tl; Andrey Nyunin, p.126; Mikael Damkier, p.139br; / All Shutterstock

Johan Skånberg-Tippen, Karin Skånberg, Paul Carslake, p.26

Launder, Sally, pp.57t, 57bl, 75cr

Newbird, p.66tl; SilverV, p.70; DarioEgidi, p.122t; / All iStock

Panom/Shutterstock, p.75tl

Philips, Nic and Stanley the dog, pp.20tr, 21tr

Plus69/Shutterstock, p.72tcl

Wang Song/Shutterstock, p.74tr

Wikipedia, p.82t

Wilkins, Phil, p.89br7

All other illustrations and photographs are the copyright of Sam Piyasena and Beverly Philp or Quarto Publishing plc. While every effort has been made to credit contributors, Quarto would like to apologise should there have been any omissions or errors – and would be pleased to make the appropriate correction for future editions of the book.

Beverly Philp
Many thanks to my family, my father and mother in-law, and an extra special thank you to Suki.

Sam Piyasena
A special thanks to Dad and Mum for their help and encouragement. Many thanks to Sandy, Vas, Sophie, Sonny and Harry. Finally, an enormous thanks to Suki for her patience and love.

We would both like to thank Moira, Lily, Karin, Kate and Julia for their support and hard work. Also thanks to everybody else who worked on the book – especially to Gareth, the supermodel!